LIGHTING AND POSING TECHNIQUES FOR

Photographing Women

Norman Phillips

AMHERST MEDIA, INC. ■ BUFFALO, NY

ABOUT THE AUTHOR

Norman Phillips was born in London, England, and became a U.S. resident in 1980. He is married, has three sons, and lives in Highland Park, IL. The Norman Phillips of London photography studio was established in 1983. A sister company, Norman Phillips Seminars, provides continuing education and services for professional photographers; it was established in 1986.

Throughout his career, Norman has been a judge at local, regional, and international print competitions and has presented over two hundred seminars and workshops across the United States and Britain. He is a frequent contributor to several magazines and newsletters, including *Rangefinder, Professional Image Maker, Master Photographer,* and *WPPI Monthly*. He has created twelve instructional and educational DVD titles and is the author of *Lighting and Posing Techniques for High Key Portrait Photography, Lighting and Posing Techniques for Low Key Portrait Photography, Wedding and Portrait Photographers' Legal Handbook, Professional Posing Techniques for Wedding and Portrait Photographers, Advanced Studio Lighting Techniques for Digital Photographers,* and *Master Posing Guide for Children's Portrait Photography,* all from Amherst Media.

Norman is also the recipient of a wide range of honors for his photographic achievements, including Lifetime Achievement Awards from WPPI and SWPP. For more information, see www.normanphillipsoflondon.com and www.normanphillipsseminars.com.

Front cover image by Paul Rogers.
Back cover images by Norman Phillips.

Published by:
Amherst Media®
P.O. Box 586
Buffalo, N.Y. 14226
Fax: 716-874-4508
www.AmherstMedia.com

Publisher: Craig Alesse
Senior Editor/Production Manager: Michelle Perkins
Assistant Editor: Barbara A. Lynch-Johnt
Editorial Assistance: Carey Ann Maines, Artie Vanderpool

ISBN-13: 978-1-58428-221-1
Library of Congress Control Number: 2007926863
Printed in Korea.
10 9 8 7 6 5 4 3 2 1

Table of Contents

Dedication

As I completed this book, the world learned of the loss of not just a photography icon and legend, but also a friend. The passing of Monte Zucker has left a void in our fraternity that possibly will never be filled. Monte befriended countless of his professional colleagues and mentored so many who now have no way of expressing their gratitude other than to pen words to his memorial.

I first met Monte when we were members of a WPPI print judging panel in the mid 1990s. When it came time for me to disagree with his urging for a higher print score, I half anticipated being put down or in some way chastised; instead, this living legend simply appealed for generosity. It was a moment to be remembered. However, it was Monte's way to consistently encourage his fellow professionals. This most admired photographer demonstrated a uniquely human emotional and almost humble persona that I was to recognize as his signature.

I am pleased to say that Monte was my friend. Working with him was rewarding and inspirational in that his primary concern was to educate and encourage those still seeking to make their mark in this exciting profession. He caused me to modify my critiques, and it resulted in my being a better teacher and mentor. Monte always had time for even the novice when approached. His generosity with his time and expertise was legendary.

Monte had a unique style that countless photographers sought to copy, but rarely did anyone succeed. His teaching was not designed to be aped but was intended as a starting point for others on their road to success.

Monte never stopped re-creating himself. He sought to break from his recognized style as he indulged in not just unique imagery but ventured successfully into the digital age with the enthusiasm of a teenager. Each time I talked to him he was excited about another venture into a new style of photography.

If we can all generate some of Monte's excitement, enthusiasm, passion, and generosity for this great profession and its practitioners, it will be a much greater memorial than any other we might consider.

Foreword

BASIC APPROACH

I recall my mother telling me how, at age five, I came home from school and told her that I was in love with my teacher, Miss Knight, a pretty lady with flowing blond hair. It was the first indication of my ongoing recognition and appreciation of the special qualities of the female species.

My observations when in the company of women have led me to a special understanding of the opposite sex. But underlying my association with women is a continuing romantic concept of women in general. It has been a strong theme in most of my portraiture of women, even when the images to be created are perhaps toward the sensual. I have an ongoing faith that women are inherently gentle and that, regardless of their individual physical makeup, each is beautiful in her own special way.

Endemic in my work with them is a compassionate sensitivity. As one of my subjects observed, I am a "sensitive male." I believe that to be successful photographing women we need to build trust by showing respect and understanding the special individual qualities that each woman possesses. While there are generalities that we might apply, they have to be taken as a starting point; each woman needs to be appreciated for who she is, not as just another woman in front of the camera. We should never enter her personal space without consent and, when directing our sessions, must avoid touching without permission (and when touch is required, it should be only with our fingertips).

ABOUT THIS BOOK

While the above discussion tells you my approach to photographing women, I appreciate that my professional colleagues may have other attitudes—particularly when the photographer is a female.

As a result, this book features a diversity of images; some that you might love, and some you might have reservations about. Indeed, while writing the following chapters, I was both inspired and challenged. Therefore, I have endeavored in my comments to identify elements that we should observe in order to learn from the images. My intention is to draw your attention to the methods used and to generate discussion by suggesting alternate techniques we could also choose to apply.

While some of the names of the contributors to this book will be instantly recognizable, others may be new to you. All have been selected because their work is of the highest caliber and they have received recognition from their peers. I appreciate their contribution to this book and hope that what is presented will help drive the reader's creativity and challenge some basic concepts about photographing women.

1. Kerry Firstenleit

Kerry Firstenleit (formerly Firstenberger) joined my studio, Norman Phillips of London, in 1996 with a degree in art and virtually no experience in photography. It wasn't long before she demonstrated a special talent as a portrait artist and was photographing sessions ahead of expectations. Since joining the studio, she has received several awards for her portrait and wedding work and has a number of accolades (prints scoring 80 or better) from Wedding and Portrait Photographers International (WPPI). More importantly, she has earned the trust and loyalty of our clientele (as well as my personal confidence).

Kerry's perspective when photographing women is not simply to make beautiful images but to draw out from her subject what she believes is below the surface. She also likes her images to be strong and prefers more contrast than less, with emphasis on personality, which is demonstrated in the portraits we review here.

I have chosen to introduce Kerry in the first chapter of this book because of her interest in classic Hollywood-style portraiture. As we begin our look at photographing women, this gives us a good chance to consider how the techniques used have changed over time—due to advancements in the equipment we use, the changing status of women in society, and the demands of the fashion world.

Kerry approached me because she had a subject she believed was ideal for a classic Hollywood-style image. I helped her by demonstrating the continuous-light techniques used to create this type of portrait, placing a pan reflector directly over or very close to the camera. This produces a flat lighting effect that can be very flattering but that is very rarely used in modern-day, flash-dominated studio portraiture. We also discussed poses used in

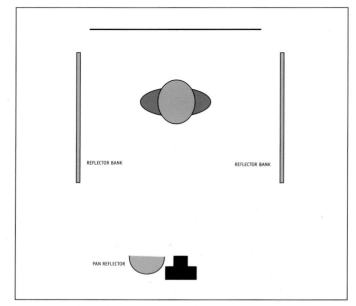

PLATE 1 (FACING PAGE); DIAGRAM 1 (ABOVE)

this type of portraiture, which were often just natural expressions of the woman herself—such as we see in photographs of Marilyn Monroe.

In her ensuing session, Kerry involved her subject in the process of creating images with style and personality. Plates 1 and 2 are typical of classic Hollywood lighting and posing styles; they have a timeless quality with a little romantic flair. Note how the head positions are tilted upward and the expressions are somewhat dreamy. In part, this reflects the need in early portraiture to use relatively slow exposures to accommodate the use of low-ISO sheet film or glass plates.

In plate 1, the woman's hairstyle reflects the vintage look Kerry was trying to create. Her head was tilted slightly upward and her eyes were focused at a point a little above the camera. The pan reflector was positioned immediately left of the camera, producing a conventional

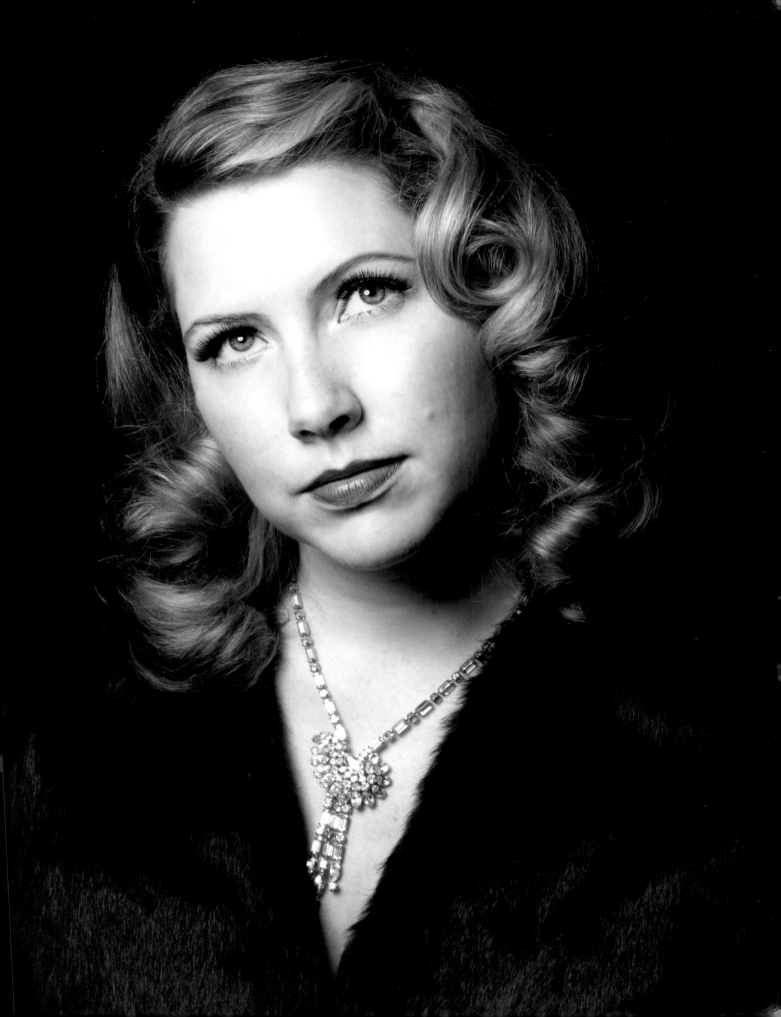

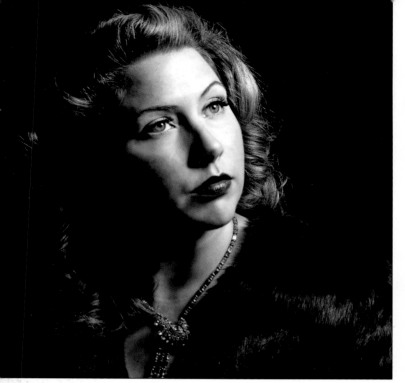

PLATE 2

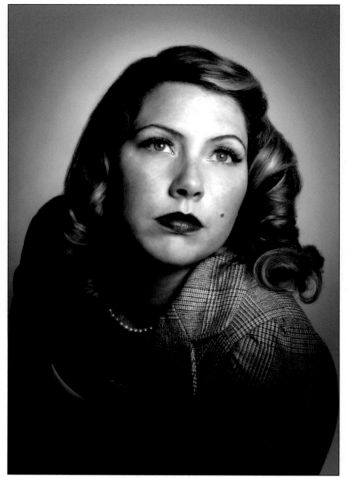

PLATE 3

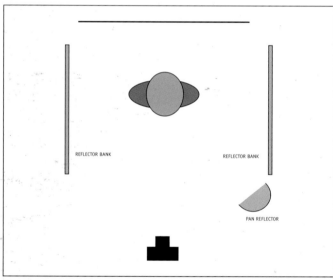

DIAGRAM 2

full-face view with strong modeling of the left side of the subject's facial structure. To create subtle lighting of the hair, Kerry used two white reflector banks, one on each side of the subject. Because of the high position of the pan reflector, no hair light was needed. See diagram 1.

Plate 2 has the subject facing 45 degrees to camera right, presenting a three-quarter view. As shown in diagram 2, the pan reflector illuminated the full face and the hair on both sides of the head while the two reflector banks reduced the ratio from highlight to shadow to approximately 4:1. Without the reflector banks, the ratio

would have been 5:1; this would be unacceptable. The final impression is both dreamy and romantic.

The image shown in plate 3 is a little less typical, yet in the same vein. There is a distinct contrast in the first two images. In plate 3, the style is the same but the lighting is softer. The contrast was reduced by employing a background light to create a slight halo effect. The camera was at a higher position, so that we are looking down at the subject who is, again, focusing at a point just above the camera.

Compare the style of plates 1, 2, and 3 to that shown in plate 4—a flattering rendition of the subject that enhances her features. In addition to being in color, the subject of this image is posed in a style that is relatively common in contemporary women's portraiture. By having her lean gently on her right elbow, Kerry created a diagonal line from the subject's high left shoulder to her wrist at the bottom left of the image. This supported the head angle so that the subject, while maintaining a con-

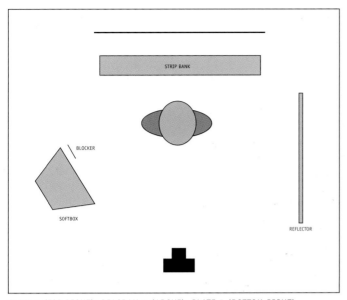

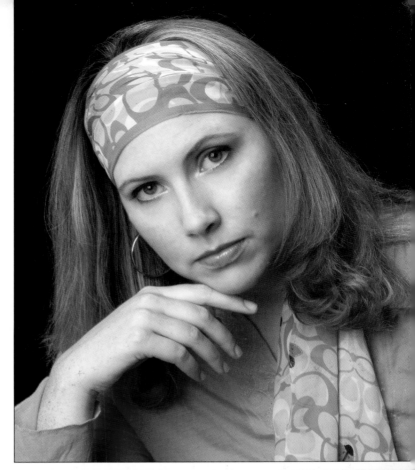

ventional full-face view, was looking at the camera. There is also a triangular pattern created by her hand and the angle of her head.

Note, too, the tight loop-lighting pattern at her nose. The main light was a 42x28-inch F. J. Westcott softbox, modified by the use of a strip blocker accessory (see glossary), which reduced the width of the front panel to create a narrow light source. Such accessories are invaluable in controlling our lighting. Kerry also used a reflector at camera right and an F. J. Westcott Strip Bank as a hair light. See diagram 3.

Let's return to some more of Kerry's classic Hollywood-style images. In plate 5, Kerry had her subject face slightly *away* from the main light. This caused the tight loop pattern illustrated in plate 4 to disappear. Instead, we see a shadow that slightly bleeds onto the left cheek. This creates a strong shadow between the left side of the subject's face and her hair. It also yields a dramatic shaping of the face that is further enhanced by the diagonal of the composition.

This pattern was not unusual in the style of portrait Kerry was emulating but is less commonly used in contemporary portraiture. This portrait, packed with style and personality, is a good example of how we can create impressive images even when using techniques that are apparently "dated."

In plates 6 and 7, Kerry created two high-key, storytelling images, again involving her subject in the process.

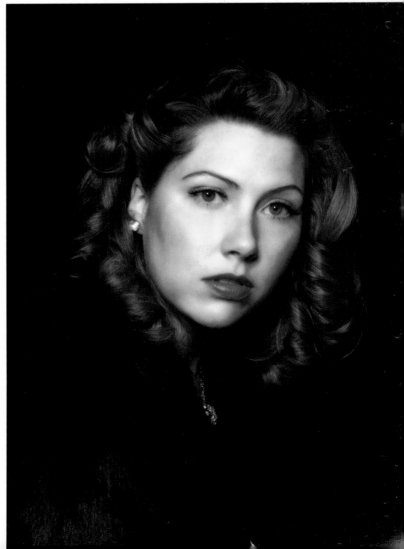

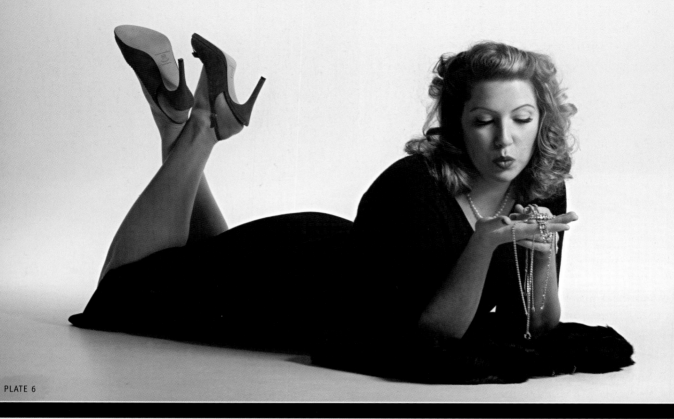

PLATE 6

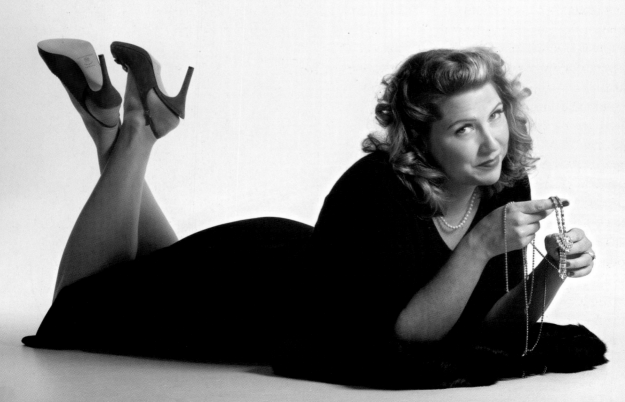

PLATE 7

As you can see, the string of pearls acts as the focal point of the story. Kerry also used a relatively high light ratio, which is in keeping with the subject's black dress.

Kerry had her subject pose on her stomach at about a 40-degree angle to the camera, using her fur coat as a base. This angle allowed her to present either a full or three-quarter view of the face. Note, too, how the legs are posed; the ankles are crossed to create a slim, feminine impression.

In both portraits, the angle of view is slightly above the subject's head, which adds emphasis to the image. To create plate 7, Kerry engaged her subject to change the look of the image, which is playful and charming.

Plate 8 is a more fashion-oriented portrait, reflecting motion and attitude. Note the posing of the subject's feet—it's almost masculine. However, because of the feminine shoes and the overall body language, it works perfectly. Normally, showing the backs of the hands is not recommended, but in an image that has this kind of motion, it is more than acceptable; it looks natural.

The main light for this shot was a 42x28-inch F. J. Westcott softbox with a single scrim diffuser. This was placed at a 45-degree angle to both the camera and subject. The top of the box was positioned just above the subject's head and aimed slightly downward.

In plate 9, the subject is either putting on or taking off her hat. This poses a particular challenge when the main light is on the same side of the subject as her raised arm, because the arm could prevent the main light from illuminating the eyes. In this situation, many photographers make the error of directing the light upward into the face, causing the features to be rendered incorrectly. Instead, the light should be directed vertically toward the subject, which was done in this image.

The portrait breaks all sorts of rules, but it is so clearly deliberate that all you see is the attitude the image conveys. Because the subject is dressed in light-toned attire, her arm is a little emphasized, yet it works well because of how the lighting is controlled. We are drawn into her eyes, which are perfectly lit. Additionally, the angle of her head produces a provocative expression that makes the unusual composition work well.

Plate 10 is an image that has elegance, attitude, and femininity. Presenting a three-quarter view to the camera, this pose has the subject with her right foot sup-

PLATE 8

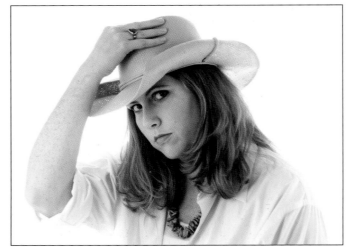

PLATE 9

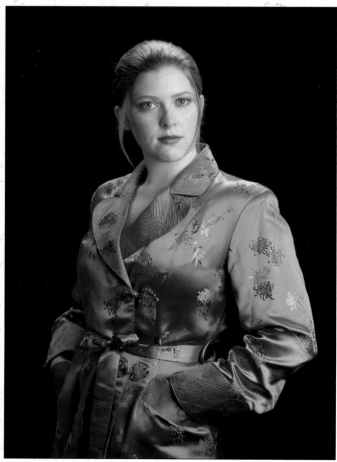

PLATE 10

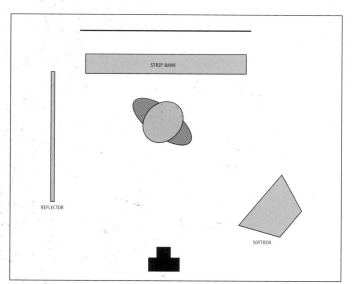

DIAGRAM 4

while her head is tipped slightly in the opposite direction. Note that having her hands in her pockets eliminates having to carefully pose them and, at the same time, adds a stylish flair.

The main light for this image was a 42x28-inch F. J. Westcott softbox. A diffused F. J. Westcott Strip Bank was used as a hair light, which also added light to her shoulders to create depth in the portrait. A reflector was used at the subject's right to reduce the lighting ratio. See diagram 4.

The stunning image shown in plate 11 has all the ingredients of portrait excellence. The S curve is well executed. You can follow the curve from her front foot, to the bend at the knee, through the sweep of her left arm, and to her head, which is tipped away from the near shoulder. The subject's hands are also beautifully posed. The color harmony was accentuated by the use of a black background, which had burgundy-gelled spotlight directed behind her for added separation and impact.

Plate 12 shows the same subject photographed with the same lighting setup, but now there is elegant motion created by the outward sweep of her arms as she delicately holds the scarf. This change adds greatly to the femininity of the portrait.

The same subject is shown in plate 13, but in a closer composition and with a relaxed smile. Cropping the image this way can make for an interesting look, as is the case here. The hand pose breaks one of my golden rules; it is my definition of the "dying swan" pose, with the hand bent down at the the wrist. Yet, it works well in this portrait because it is perfectly natural, and Kerry took pains to delicately pose the fingers. The light for this portrait was the same as that for plate 10, but the main light was modified by adding a second diffuser and bringing the reflector a little closer to open up the skin tones on the subject's right cheek.

Plate 14 is a delightful portrait of an elegant grandmother at a window. The main source was unmodified window light, and a reflector was used to fill the shadow side of the portrait. The lady was seated sideways on the chair with her left arm gently resting on the chair back. Because of the height of the chair back Kerry could not employ my "live swan" hand pose (with the hand bent up at the wrist), so she used a completely different concept, stretching the fingers out toward the subject's chin. By

porting her weight as her left leg is allowed to relax and bend at the knee. Even though we are unable to see her full figure, we are able to see the desired S curve created by having her shoulder slightly turned to the camera

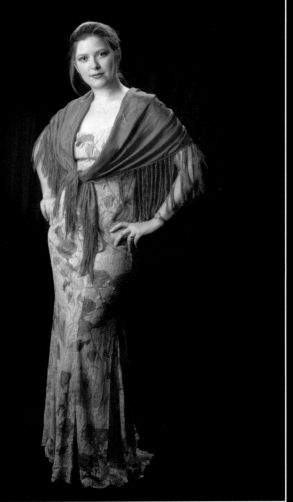

PLATE 11

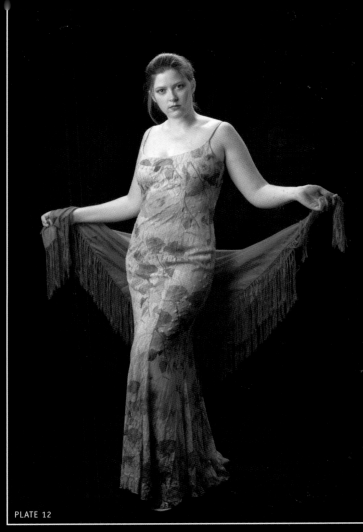

PLATE 12

PLATE 13

PLATE 14 (ABOVE); PLATE 15 (RIGHT)

bringing her right hand to the back of the chair a leading line was created that takes us right to the subject's face and her slightly quizzical smile. It is a portrait that reflects this woman's character and personality, and it's worthy of a place on the family wall.

Plate 15 is something totally different from all the previous images by Kerry. It is a high-key, through-the-veil profile of a bride that is delightfully delicate and engaging. The main light was slightly behind the plane of the subject. This light, diffused through the veil, created just enough specular highlight on her cheek, forehead, and nose. The close cropping adds to the mystery and charm.

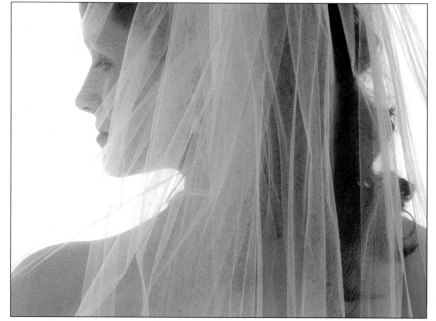

2. Michael Ayers

Michael Ayers has earned numerous prestigious awards from both PPA and WPPI. He has a PPA Masters Degree, is a PPA Certified Professional Photographer, and has a PPA Craftsman degree. Michael has also received an Honorary Accolade of Lifetime Achievement Award from WPPI. Michael is a regular presenter for both PPA and WPPI, and he writes technical articles for numerous professional photography publications.

In plate 16, Michael created a very attractive black & white portrait with a 3:1 ratio. It is a gentle impression that appears to reflect who the young woman is. The subtle sculpting of her features was accomplished with the main light at 45 degrees off both subject and camera and a fill light a bit less than one stop lower than the main.

Note that the subject's head was tipped toward her near shoulder. This position is traditionally feminine and gives the portrait a demure look. We should use this head position only when it suits the personality of our subject and the look of the image.

Michael innovates by angling his camera to create diagonals. The subject was seated virtually upright, and Michael determined that the composition lacked the dynamics he wanted, so he tilted his camera to his right, causing the subject to appear to tilt to our left. This is a technique that can save valuable time when seeking to create as many attractive images as possible in the shortest period of time.

Plate 17 shows a pose that is often used with high school seniors and, as is also typical, the image was treated with an edgy effect. The image falls into middle key. The pose is open and innocently fresh and one that many young women age seventeen and older are very

PLATE 16 (TOP); PLATE 17 (BOTTOM)

PLATE 18

comfortable with. The ratio is a little less than 3:1. When using such a short ratio in portraiture a soft light will always produce the most acceptable impression. The catchlight in the subject's eyes is at about 12 o'clock; this tells us that the main light was positioned very close to the camera.

By having the young woman laying on the floor and positioning the camera a little above her head, Michael caused her to open her beautiful eyes for the portrait. This angle works very nicely with the younger female subject.

The pose of the young lady in plate 18, another middle key image, shows a totally different approach. The lighting style is virtually identical to that in plate 17; it is soft and a little less than a 3:1 ratio. The soft lighting created a very gentle butterfly-shaped shadow that is barely perceptible, and the shadow below the subject's chin is equally gentle. The slight smile, the soft lighting, and the

angle of view are perfect for a female subject at this age, showing a youthful glow with a little innocence.

The main light was placed at camera left and the fill light was positioned relatively close to the camera.

To create the image shown in plate 19, Michael posed his subject in an outdoor location with the primary light source behind her and to her right. This light slightly rimmed the shoulder and the right side of her face, and a supplementary light filled the frontal plane of her face. (See diagram 5.) Depending on your skill in light control you may either use a reflector as the fill or use a controlled and diffused flash unit. In this example, the ratio is almost 3:1. Soft light like that shown in this image produces beautiful skin tones.

The young woman was posed leaning on her left elbow but without putting all her weight on it so that her shoulder was not forced upward, which would break the nice line across the shoulders. This pose automatically

tipped her head away from the near shoulder, avoiding the submissive head pose.

In plate 20, Michael had the same subject roll away from the camera to produce a dreamlike profile. As the sunlight was diffused, there was little need to use a flash or reflector for fill, perhaps less than a half stop. The pose shows off her long neck line, something we may forget to present to our subjects. This is a very nice angle to show how pretty she is. A variation on this exceptional portrait could be created by having the far shoulder bared.

In plate 21, Michael had his subject lean against the background wall with her head slightly tipped downward

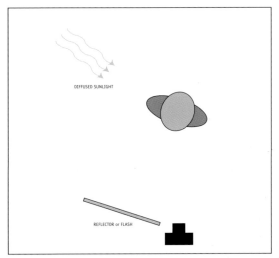

DIAGRAM 5

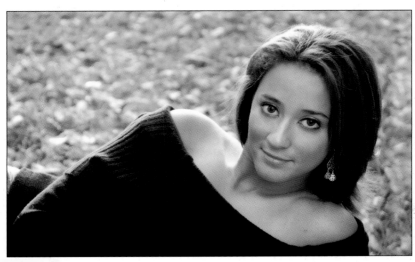

PLATE 19

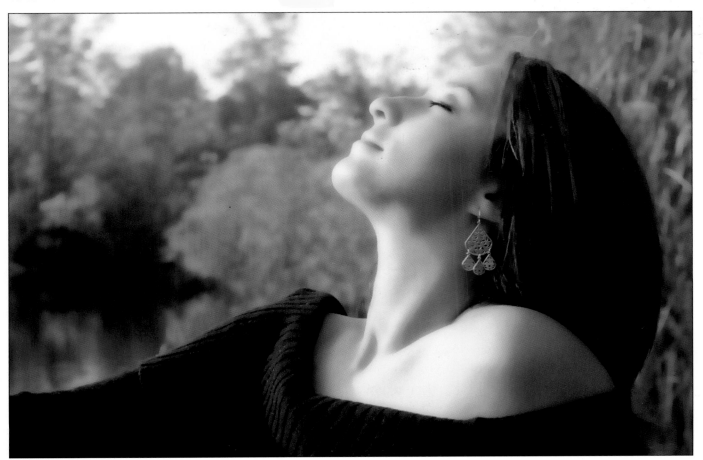

PLATE 20

PLATE 21

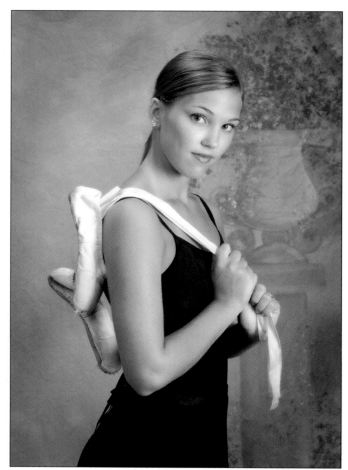

PLATE 22

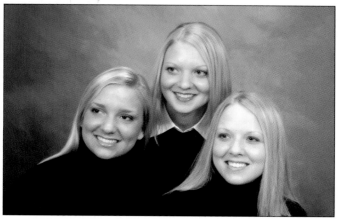

PLATE 23

and turned toward our right. Whatever he said to her caused her to direct a somewhat provocative expression to the camera. It is another example of generating different expressions by having our subject change head positions. The lighting ratio is again almost 3:1.

Plate 22 shows the subject standing profile to the camera with her head turned to present a three-quarter face to the camera. The subject is obviously into ballet, and the use of the shoes draped over her shoulder offers another option when photographing subjects involved in this discipline. This pose will frequently produce an interesting expression like this when the head is turned to the camera from a profile base. Again, the lighting ratio is almost 3:1, and the image falls into middle key.

Plate 23 is a delightful portrait of three blond young women lit in a 3:1 ratio with a background that set the overall image in middle key. The main light was placed quite close to the camera and created a very soft feminine impression. The posing created a lively composition because no two heads appear exactly on the same plane. The slightly undulating composition is much more interesting than having the heads all lined up together or in the more common triangular composition.

Note that the camera was placed very slightly above eye level of the young woman at the back of the group. This perspective is valid in the great majority of female portraiture.

Pregnancy portraiture has become very popular. There are many different approaches that can be used in this type of portraiture, and the low-key portrait shown in plate 24 is but one. In this example, Michael used a profile pose for the face, which is tilted down to look at her belly. He positioned the mother-to-be's body at an angle to provide a view across her torso and emphasize its shape. This time Michael used a full 3:1 lighting ratio to sculpt the woman's facial features.

The main light was a softbox placed to camera left, and a second softbox was positioned above and to the right of the subject. In each case, the near edge of the softbox was level with the subject. The overall impression Michael created in this shot is different than in most maternity images we are accustomed to—it is very soft and delicate.

The next three examples are bridal portraits. It is important to remember that a bride is a woman and should be treated as such. Therefore, in a book on photographing women, bridal portraits have their place.

Plate 25 shows an image taken with a daring approach. The camera was high above the woman's head

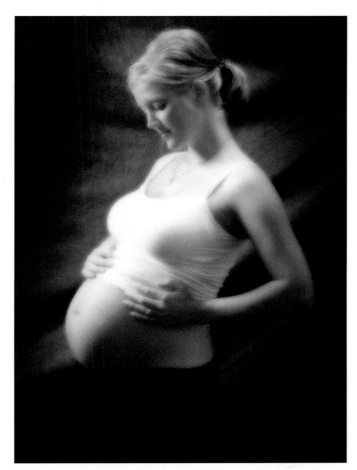

PLATE 24 (RIGHT); PLATE 25 (BELOW)

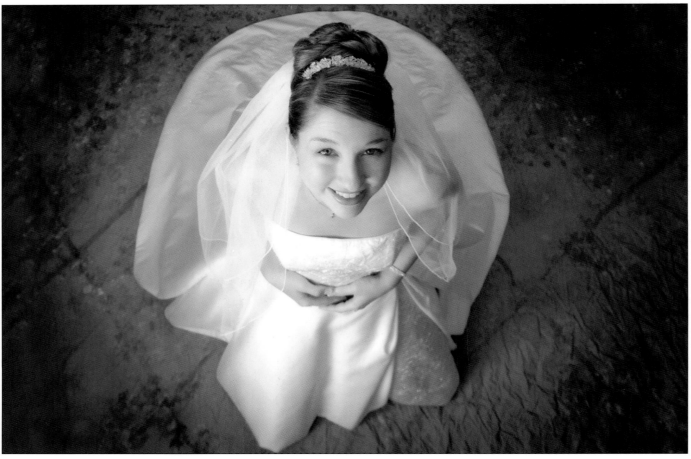

PLATE 26

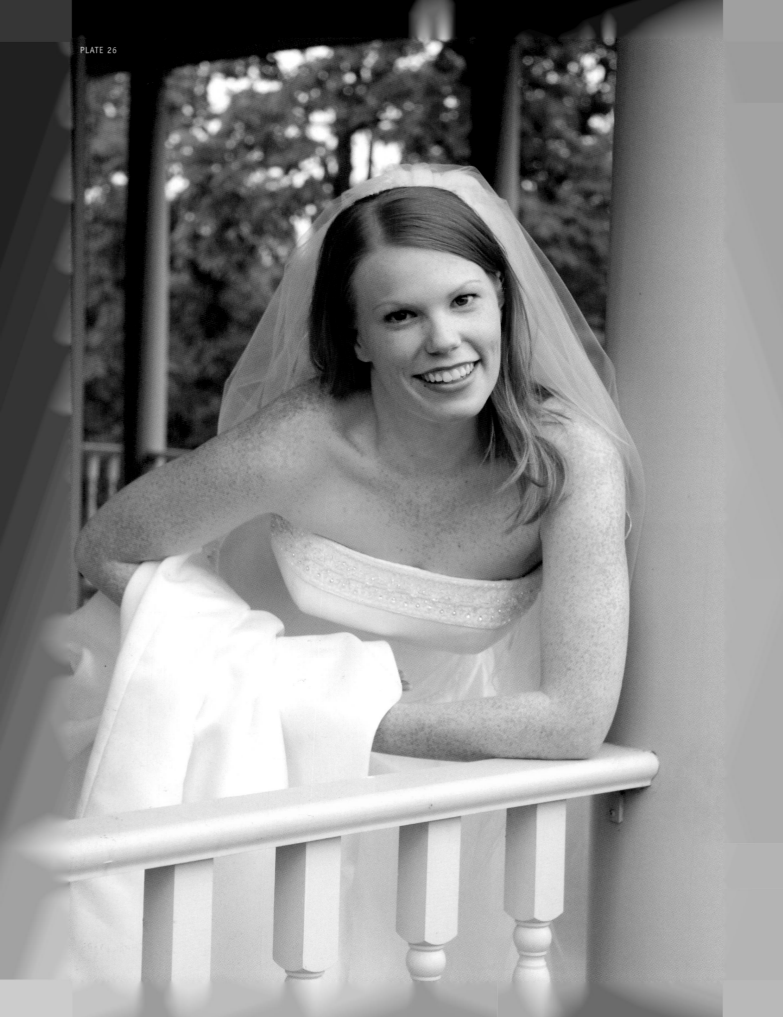

and caused her to look upward. The expression is great, and the effect of the camera angle is a little bizarre but fun. The main light was positioned to camera left, and we have a 3:1 ratio.

This unusual approach will produce interesting comments from professional colleagues and clients.

The bridal portrait in plate 26 is relaxed and fun too. The portrait was made with available light with a little direction from our right, but it is the subject's pose that makes this image so engaging.

By placing her left elbow on the rail and her right forearm holding her gown, her head naturally tipped away from the near shoulder, creating a nice head angle. Since only one elbow was positioned on the rail, she did not hunch over her hands. Her expression says it all.

In plate 27, Michael had the bride tip her head toward her near shoulder; this works very nicely in this portrait. The angle of her head is a gentle diagonal from top left to bottom right. The lighting was soft and resulted in a little less than a 3:1 ratio. This lighting style opens up the full face of the subject by keeping the shadow areas as light as possible without flattening them as we might in a glamour shot. This relatively flat lighting will not disguise the shape of a subject's face as will a longer ratio produced with directional lighting.

Plate 28 is a delightfully feminine presentation of a bride photographed by window light. There are three important elements that make this portrait special: The first is the three-quarter view of her figure to the camera, which was also slightly turned away from the direction of the light. This allowed the light to skim across her gown, emphasizing its beauty. It is a technique that should be used when we wish to show the maximum detail in a gown or enhance a bustline. The second outstanding element is the beautiful profile lighting, and the third is the serene position of her hands. The hands and arms create a gentle leading line to the head, which was presented in a profile position. All three elements create an exquisitely feminine image.

Most of Michael's images shown here consistently use a soft, slightly less than 3:1 ratio, an approach that defines his style.

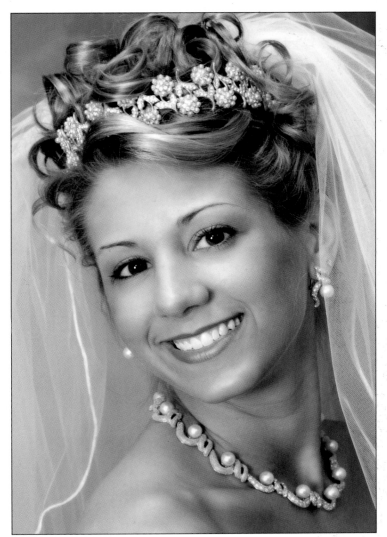

PLATE 27

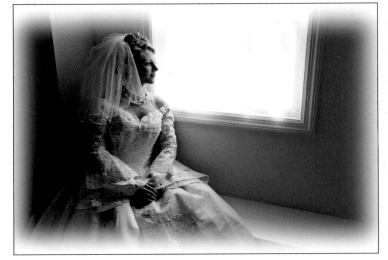

PLATE 28

3. Andrea Barrett

Andrea Barrett is one of Britain's best-known wedding photographers and a much sought after presenter to professional photographers. She has a Fellowship with the Society of Wedding and Portrait Photographers (SWPP), a Craftsman Degree with Britain's Guild of Wedding Photographers, and is an associate member of the British Institute of Professional Photography (BIPP).

Andrea's portraiture is exceptional in that it optimally defines her subjects' femininity. She captures moments that show the emotion and grace of movement that the female subject projects when encouraged to let go and express herself. These shots depend on great timing, anticipation, and recognition. None of the images in this chapter are photographer posed, and all are captured by available light.

In plate 29, Andrea's back view of her bride demonstrates feminine elegance. The natural light came from 10 o'clock and, as a result, the gown and the bride are beautifully illuminated. The light through her headpiece lends a celestial effect. This is a case of recognizing where the light is and at which moment to capture the image.

Plate 30 was created by encouraging the bride to demonstrate her happiness. The image is a totally feminine expression captured on an overcast, windy day. This is a pose that would be difficult to arrange without it appearing fake. Capturing portraits in the free posing style requires preplanning so that the subject is in the right place. When we capture these images our portraits have a much better impression of reality.

PLATE 29

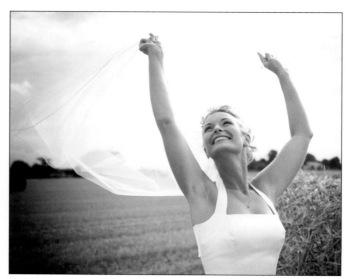

PLATE 30

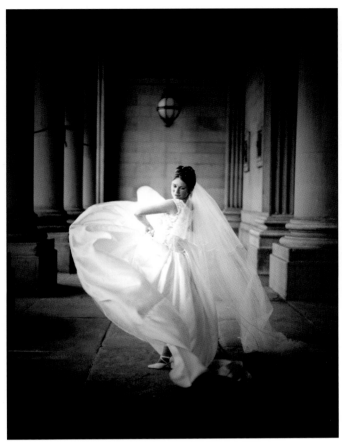

PLATE 31 (ABOVE); PLATE 32 (TOP RIGHT); PLATE 33 (BOTTOM RIGHT)

Plate 31 required anticipation and timely execution to capture the light from camera left. The image was created when the bride was prompted to indulge in a flamenco-style dance. At the moment of capture the light created a conventional lighting pattern on her face that made her likeness recognizable. There is a rhythm and motion in the portrait that is very attractive. The low-key environment made the image more striking.

In plate 32, Andrea positioned her subject near a full-length window distant enough from the wall behind her so as to record it in low key. The pose is one that women can be seen to take up without instruction. The subject's arms were extended full length between her knees to create a leading line from her hands to her profiled face.

The lighting created a strong contrast, and the shadowed areas have no detail, which is unusual in bridal portraiture. We cannot determine a lighting ratio when there is no detail in the shadows, but if we were to guess, we would suggest it is 6:1—extremely high.

Plate 33 shows the bride spinning around toward the camera, presenting a delightful impression of someone in

PLATE 34 (ABOVE); PLATE 35 (LEFT)

a moment of real happiness. The flow of the gown accentuates the femininity of the image. The image was created in shade, and if there is a hint of specular highlights it is because the light came from behind the subject. Andrea demonstrated what she wanted the subject to do, then simply asked her to throw her dress around and keep smiling.

At weddings we need to remember that the bride is not just a bride but also a vibrant female at a time of great excitement. Too often bridal portraits simply show the gown and bouquet, presenting a somewhat stiff and statuesque impression that, while pleasant, may not reflect the subject's sensuality.

Plate 34 shows an innovative approach to creating a soft and sensual image. There is a little intrigue inherent in the image because we see only half of the subject's face. Even though soft focus was used we are drawn to her eye. Andrea used the shape of the urn handle to mimic the shape of the nose.

The image was captured on an overcast day, and no reflector was required.

The portrait in plate 35 was created with soft, cloud-filtered directional sunlight from the right. The portrait conveys a little attitude as well as the desired sensual curves from the bottom of the gown all the way to her head. These elements make for a sexy combination that is sure to appeal to the groom.

The subject placed her weight on her right foot and relaxed her left leg, which caused the break at her knee. The fact that she was turned slightly away from the camera and extended her left hip enhanced the coveted S curve that we seek to create.

In plate 36, Andrea accentuated the impression of freedom by tipping her camera to her right for a more dynamic effect.

The sunlight came from above the subject and was filtered by clouds on a slightly overcast day. Having the subject look skyward allowed the light to model her features. Andrea was looking for an Audrey Hepburn im-

pression, and the gown made that possible. This pose classically demonstrates that we can use our subject's clothing to create different impressions and show her femininity.

PLATE 36

The image in plate 37 is a classic fashion-style portrait like the ones that are often seen in magazines. The pose is completely natural; had Andrea tried to "correct" her positioning by bringing the woman's right hand around so that the arm would run across the camera, the image would have better conformed to the traditional rules of

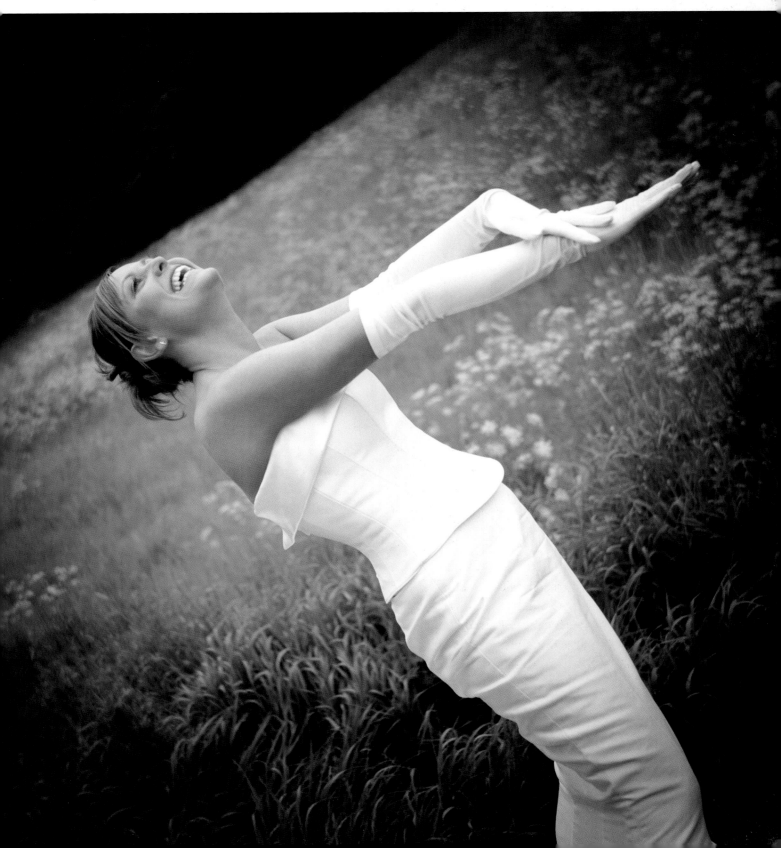

good posing—however, the impromptu feel of a fashion image would have been lost.

The exposure was calculated on the spotlight from above and a little window light. While some would advocate the use of fill to reduce the shadows between the subject's chin and bustline, in this instance it would have destroyed what is an interesting and attractive portrait.

While the principles of good lighting should always be our concern, there are times when the scene in front of us is best captured as is.

The image in plate 38 was created when the bride was running upstairs to a landing lit by a window. The flowing hair and bared, shoulder supported by the white gown, are intriguing. Using movement and light from angles that are not often used can produce images that are not only feminine but also have a little mystery. Women often appreciate this type of imagery.

Andrea created the supermodel image shown in plate 39 on the beach at late afternoon (about 5 o'clock). The sun was at about 3 o'clock, casting a strong shadow behind the subject and creating a clean rendering of her face. A supermodel-style portrait with this lighting is always a winner; to fill in with either a flash or reflector would have diminished the impression.

The subject's pose produced the desired S curve, and her motion and the strong natural lighting enhanced the

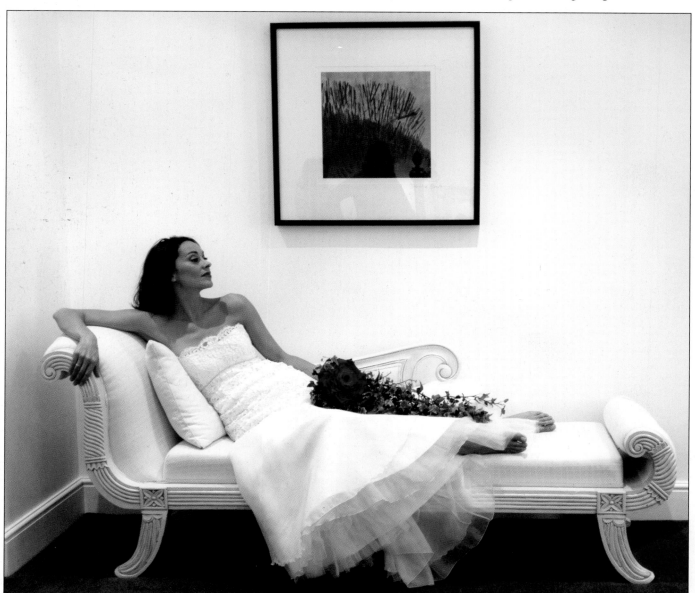

PLATE 37 (ABOVE); PLATE 38 (FACING PAGE)

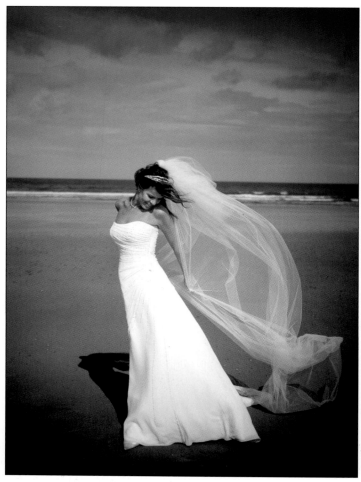

PLATE 39

PLATE 40

impact of the shot. This image proves once again that anticipation and timing can yield an image with soft, feminine curves.

To produce the image shown in plate 40, Andrea placed the bride in a unique location between surrounding rocks and in front of the longest waterfall in England. With only weak light coming from above and slightly to camera left, she was faced with a low-key set. By having the subject tilt her head up toward the light Andrea created a strikingly beautiful low-key portrait. The almost split lighting created a slimmer presentation, and the deep shadows created a sense of drama.

Note that the bride's weight was on her left foot and her right was relaxed; this caused the leg to break at the knee, accentuating the S curve. Extending her arm with the bouquet prevented the composition from becoming static.

The purpose of this chapter is to inspire different and creative portraiture of women. While the forgoing images are from wedding assignments, each offers us posing and lighting strategies that we can use when working with any of our female clients.

Klarke Caplin is the recipient of several FujiFilm Distinction Merit Awards and holds an Associates degree with the British Institute of Professional Photographers. Her clients include Associated Press (AP) and Camera Press. Her work has been published in *OK, Hello, Brides,* and *You and Your Wedding,* to name just a few. She travels on assignment throughout the U.K. and overseas.

Klarke is essentially a photojournalist, and her style is innovative and contemporary. The images in this chapter challenge many of the norms, but Klarke makes no apologies if her images shock the purists. It is all about capturing the moment. Her assignments are wide ranging; Klarke shoots corporate, PR, travel, fashion, and wedding images.

Plate 41 is the result of cross processing color film. The provocative pose shows a lot of attitude. Posing the subject in profile and

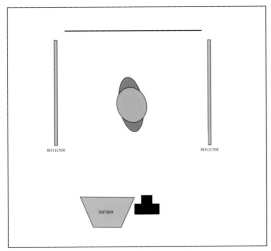

DIAGRAM 6 (ABOVE); PLATE 41 (RIGHT)

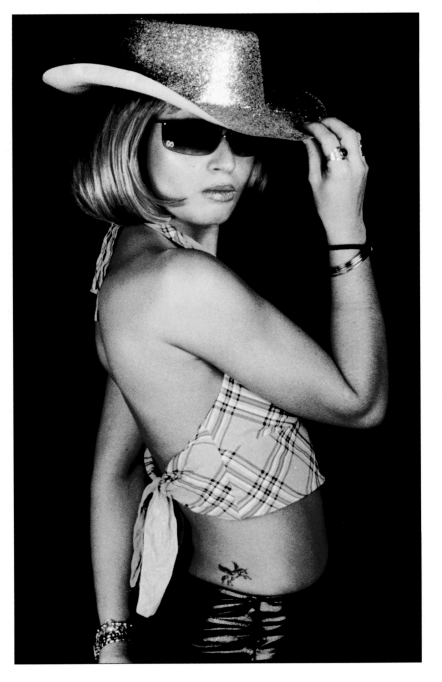

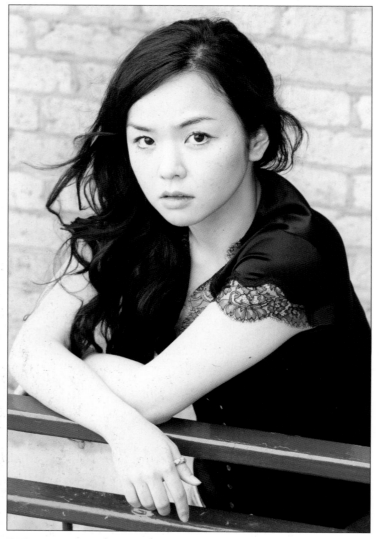

PLATE 42

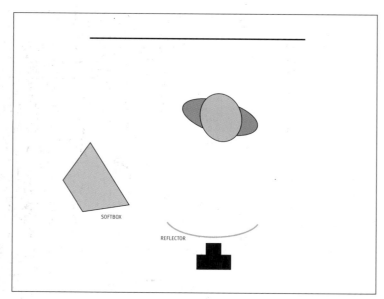

PLATE 43 (FACING PAGE); DIAGRAM 7 (ABOVE)

having her turn her head toward the camera will always provide interesting expressions with a little encouragement. To complete the pose, the subject positioned her fingers on the far side of her hat. The use of a black background made for a striking image.

A 48-inch softbox was placed slightly to the left of the camera for a flat lighting effect. Two large reflectors, one each side of the subject, provided additional definition and modeling. See diagram 6.

In plate 42, the subject rested her elbows on a railing to create a relaxed composition. Klarke allowed her model to be comfortable and did not tweak the position of her arms and hand, so the resulting portrait has a casual look.

Note that the subject was turned slightly away from the camera, with the lens positioned slightly above her forehead. The angle of view caused her to raise her eyes to the camera with a quizzical expression.

Strong sunlight from camera left was the primary light source for this image. Flash was used to camera right to eliminate deep eye sockets and harsh shadows. The flat lighting, which is used often in glamour portraits, eliminated almost all the shadows and skin imperfections.

In plate 43, Klarke had her subject shake her hair around to provide a natural and spontaneous pose and one that is likely to be attractive for the younger subject or fashion-conscious client. It is very effective when the subject has long, cascading hair. This subject had hair just long enough to make it work. We see this technique used on TV advertising hair products.

The main light was a small softbox placed to camera left and a little higher than her head. A domed reflector was placed below the subject's face. A background light was used to create a slight haloed effect. See diagram 7.

Plate 44 is another image that has the glamour treatment. The relatively static pose has impact due to the use of the red metallic dress. The subject's head was slightly tipped to our right, breaking the vertical line of her torso. The position of her arms is one we frequently see, with matching lines created by the arms. The impression could be dramatically

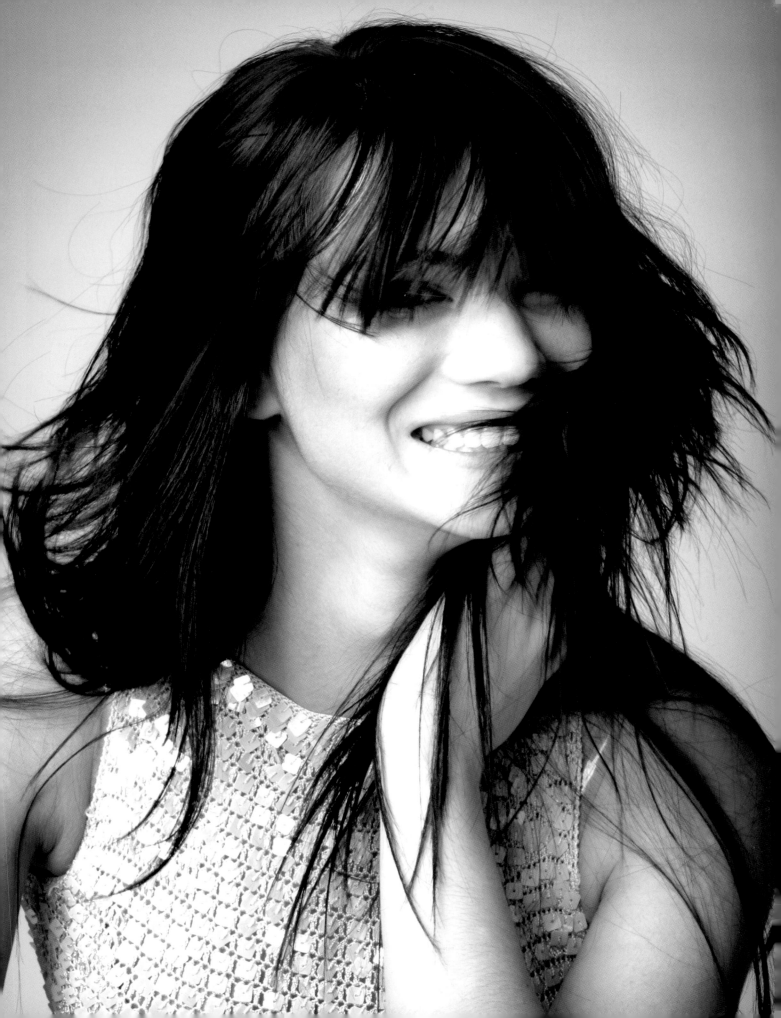

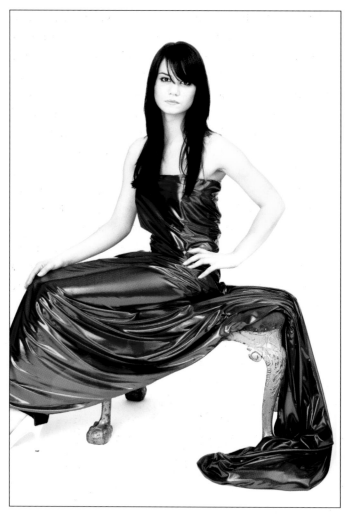

PLATE 44

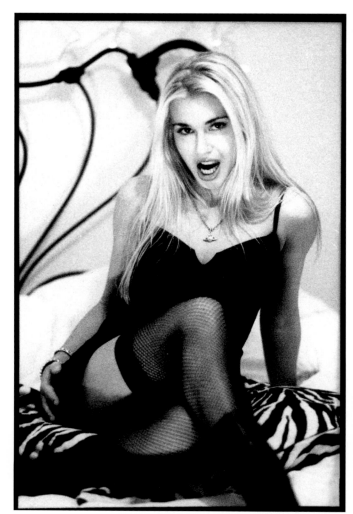

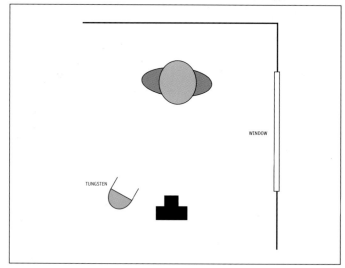

PLATE 45 (TOP); DIAGRAM 8 (ABOVE)

changed with her head tipped a little to our left. Another change that would create a different impression would be to have her extend her elbow toward her right knee.

A standard high-key background was used and a light was placed at each side of the camera to create the flat, glamour-style lighting.

Plate 45 is a provocative image with sex appeal. The subject is attired in black lingerie, challenging us to respond to her presentation. For those interested in boudoir and glamour photography this is a good starting pose. The placement of her hand on her right hip is suggestive, and the raised knee created an attractive, boldly feminine impression. The raised knee also reduced the view of the black top, which provided another feminine element to the composition.

The lighting was mainly from a window to our right and her face was lit with a tungsten spot from a low angle

to our left. See diagram 8. The high-key set elements, black garments, and black props produced a dynamic fashion image with a glamour edge.

In plate 46, the subject was positioned in a casual leaning pose against a window, which created a high-key background and also eliminated a lot of detail in her hair. The front of the image was illuminated with a little flash and a reflector. The facial rendering is different from any we have so far seen and is in some ways reminiscent of what we see in everyday lighting situations.

Teenaged subjects often prefer a passive, almost disinterested expression as shown here. To bring another type of client to our studio it is a good idea to show some different impressions such as this, a portrait not unlike those we see in the windows of hair and beauty salons.

The pose shown in plate 47 is almost a conventional three-quarter face. However, it was shot from a lower angle than we would expect to see. This caused the subject to look a little downward at the camera, thereby evoking an interesting expression. The slight tilt of her head to our right is what makes this portrait work so well.

The subject was photographed against a high-key background. The primary light for the image came from a skylight. Fill flash was used from the left, and an array of silver reflectors was used to open up all the shadow areas for a flat-lighting glamour style look.

In these images Klarke has challenged our conventional concepts in both posing and lighting and shown that there is a lighting style for all purposes and needs, providing we want to explore different techniques.

PLATE 46

PLATE 47

5. Tony Corbell

The who have been at national and international photography conventions will be familiar with Tony Corbell. His presentations, "Power Lighting for Power Clients," are always a sell out. Tony also is a respected print judge at national and international competitions and is a frequent presenter of Master Classes.

Tony says, "My favorite subjects are women. I find women are more fun, less likely to be rushed, more likely to be spontaneous, and more likely to express themselves." Tony finds men boring subjects and says that with women, there is more opportunity for posing and more freedom in every sense.

As you can see, a split lighting effect was used to capture the image shown in plate 48. The light was all from a window at our right with the subject facing square to the camera with her elbows on a table.

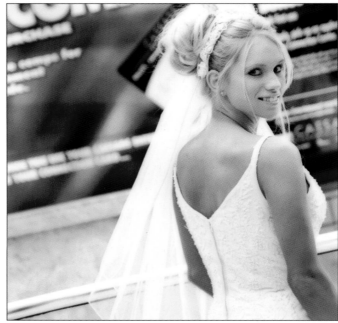

PLATE 49

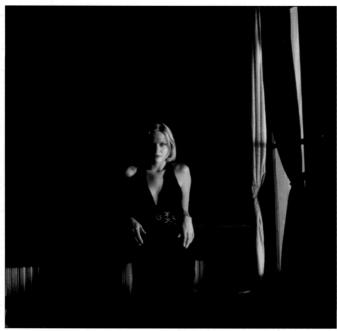

PLATE 48

This natural-looking pose required little if any direction. It is not a classic portrait pose but is especially effective with this lighting and the woman's attire, which blends with the background. The elimination of all detail from the background provided a dramatic impression. Including the curtains that reveal the source of the light and the areas of light at our left is a classic demonstration in how to use space in our composition. The expanse of dark space in the image creates added impact.

Unoccupied space was used once again in plate 49 and enhanced the composition. The angle of the bride as she looked over her shoulder at the camera created a fun image that would have been compromised if it were cropped to include her alone. The angle also provided a minimum of shoulder width to create a narrow view of her waist and a nice presentation of the bustline.

The lighting in plate 50 is ideal for a subject with darker skin tones. The soft light under an overhang eliminated the possibility of creating the hot and reflective skin tones that would likely have resulted if she were in bright sunlight. Tony also recognized the value of the reflected light from the wall behind the subject and the slightly stronger ambient light that created a gentle highlight on both her fingers and her face.

The horizontal and vertical lines are examples of how to use the environment we find ourselves working in. The pose has leading lines running from any starting point at which her arms are resting on the rail to her head. Note how Tony positioned her arms at the rail to create leading diagonal lines. Another line runs from her right shoulder all the way down her right arm and then up and around her left. The fingers of her right hand are perfectly posed.

Plate 51 is beautifully lit and has a delicate vibrance in the skin tones that we should all seek to achieve.

The pose is also of interest. The straight line of the subject's figure says so much about her—clearly this is a self-confident woman who is very comfortable with herself. Sometimes when we are posing our subjects we take something away from the person with the pose we direct. If this is who she is, then we should include such an image for her selection.

Note that Tony has elected to crop the image in such a way that the top of the head is clipped off. While strict traditionalists might avoid this, it's a technique contemporary photographers often use effectively to direct the viewer's attention to the subject's face.

The lighting falls into the high-key category, as the background is very bright. The available light coming from the left is both soft and directional. The ratio from the highlight side at left is 3:1, which is perfectly acceptable in this style of portrait.

Plate 52 is an example of how a "masculine" pose can work beautifully with a female subject. Tilting the cam-

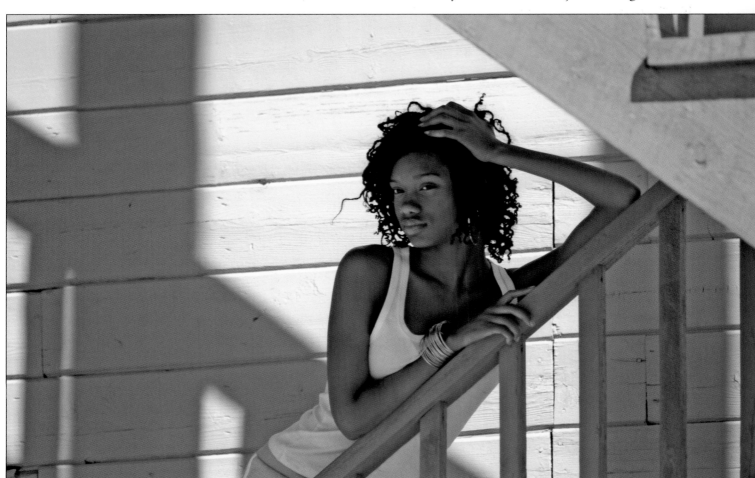

PLATE 50

PLATE 51

PLATE 52

era slightly to the left increased the dynamic quality of the image. The woman placed her weight on her left foot, and her right foot was allowed to rest loosely, which caused the break at the knee. Hooking the left thumb in the pocket is what men do, and occasionally we may see a woman do this too. If the camera had not been tipped, we would have noticed the left shoulder resting lightly against the doorjamb to create a little width.

The natural frontal daylight beautifully illuminated her face with enough sculpture to show her attractive features. The light rendered beautiful skin tones throughout the portrait. Positioning our subjects in the right place based on the light source is critical to effective lighting.

In plate 53, Tony went for a simple seated pose. By having his subject put weight on her hands he brought her head over her knees. Otherwise, they would have extended beyond her head position, creating a distraction and compromising the pose.

Again, Tony placed his subject perfectly in the field of soft yet directional natural light. It beautifully modeled her face with gentle highlights and flattering skin tones.

Note that the subject's placement in the right-hand half of the composition left space for the image to breathe; cropping to a narrow composition would not have given this image the same impact.

Plate 54 is another image that was created with natural light—and one that could have been created with the use of a softbox if working in a studio environment. Notice that the forehead, nose, left cheek, and chin are lit, but the right cheek is missing the kiss of light we might look for in a traditionally lit portrait. This effect lends a little mystety to the shot and also draws us into the subject's expressive eyes.

The sloped position of the hand and arm created a pleasing diagonal that is critical to the natural-looking pose in this tightly cropped portrait.

Note the careful, delicate, and feminine posing of her fingers. Little things can make a lot of difference to the appeal of a portrait; having the patience to attend to detail is important. Little things often help to create greater interest in the composition.

In plate 55, Tony again used natural light to capture a relaxed portrait. Notice the unusual cropping of this image, which is clipped at the top and bottom. While this might not work in a very traditional portrait, it's perfectly acceptable for more contemporary looks.

Having the subject throw the jacket over her shoulder and present a three-quarter view with a happy expression, Tony created the sort of image that will appeal to clients who do not see themselves in a formal pose. Many clients are not attracted to the more formal type of images that grace many photographers' studio walls. You may find that adding images like this one to your displays will open up a new segment in your market.

The soft daylight with a slight directional quality from the left sufficiently modeled the subject's face so that it was not flat lit. Note that there is also modeling in her bust; this is essential in most portraits of women.

Plate 56 is an image similar in style to those by Kerry Firstenleit in chapter 1. However, in this portrait, Tony employed a light at the left of the subject that skimmed her shoulder and the left side of her face. A second light placed high to camera right illuminated her gown and

PLATE 53

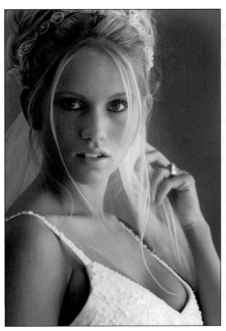

PLATE 54

PLATE 55

PLATE 56

created a kicker light effect on her neck and below her jaw as well as on her left shoulder and chest. This is a form of the opposing light technique in which light from

both sides is intended to create similar effects on both sides of the image. A third light lit her right shoulder and outlined her arm. Note the tight loop on the left of her nose and the shadow below her right nostril, a treatment that was common in the 1940s through the early 1960s.

The pose Tony arranged is also typical of the period. The subject faced three quarters to camera right and turned her head exaggeratedly to the left, with her face tilted upward in a theatrical impression. It's the old movie star pose.

Plate 57, titled *Elena,* is delightfully feminine. If we search our memories we will recall many times seeing a female place her hands in front of her mouth and nose in reaction to a comment or an unexpected situation. In this example she has a complementary-colored fabric in her hands that makes the image that much more intriguing. This is an example of using the natural tendencies of our subjects to create attractive images. We might elicit this reaction by engaging a woman in conversation or suggesting something personal.

Tony used available light from camera left to create a 3:1 ratio. Note the way Tony used space at the left of the composition to draw us to the pretty face at the right.

When first reviewing the portrait in plate 58 my reaction was to say no, don't do this. The arm creates a long white line that runs diagonally across the frame and draws the viewers' attention. Also, we might wonder whether the arm is hers or someone else's intruding into the composition. But the more I looked at the image, the more I liked it because, no matter how much the arm drew my eye, it took me to the subject's face. It is a case of the exception to the rule that proves the point.

A single softbox was placed at 45 degrees to the camera and subject and at a height of about 1 o'clock. The image is simple but effective.

Plate 59 is a commercial shot taken in a mattress store. The entire area was evenly lit primarily from the left of the subject, and additional light was directed from the right of the camera to highlight the woman's jacket and reduce the ratio. Another light was employed close to the camera as a fill light. The result is a lighting ratio of a little less than 3:1. The overall lighting is typical of commercial shots created for advertising purposes.

The pose is a simple one. The subject placed her weight on her left foot and relaxed her right leg. Her

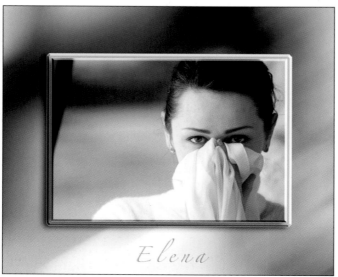

Elena

PLATE 57

PLATE 58

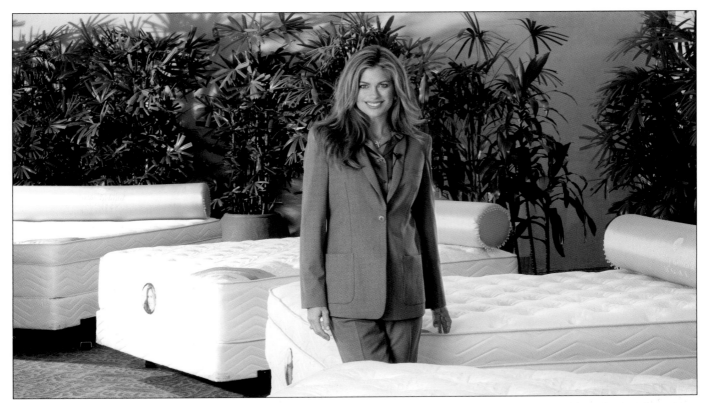

PLATE 59 (ABOVE); PLATE 60 (RIGHT)

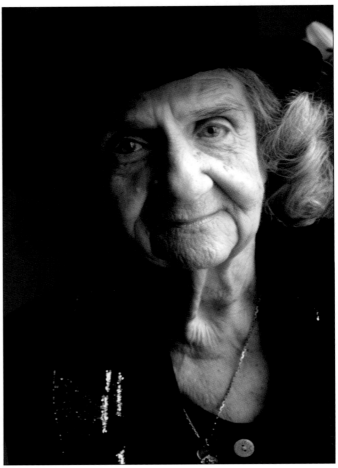

right hand rested by her side. The tips of her fingers of her right hand touched the mattress behind her. The very slight tip of her left shoulder toward our right softened the impression.

Plate 60 is a great portrait of an elderly lady created with available light. The tilt of the head, whether by tipping the camera or by having her leaning very slightly to her right, provides a diagonal pose that adds to the dynamic quality of the image.

The above-average contrast in a portrait of this type is a little unusual, especially when the subject is a woman. Most photographers would want to soften the impression by employing a fill light, perhaps a reflector at the camera position. But this impression is strong and has great character. The lighting adequately meets the demand to light the mask of the face. There is light on all five elements and a butterfly-shaped shadow at her right with the better than 5:1 ratio running from her eyebrow all the way down to her chin. It is an impression completely different from that created by Kerry Firstenleit in plate 14.

Portraiture is about creating the desired impression, and this is not always dependent on creating a standard

PLATE 61

lighting pattern or lighting ratio. Much of the time we will make a decision on the lighting based on what we see and will work without any preconceived concept.

Plate 61, a portrait titled *Liz,* is different from those previously reviewed in this chapter. The subject is posed with a challenging expression. The angle of her shoulders, slightly tipped to her right, and the opposing head angle makes for a portrait that suggests she needs an answer to a question. The portrait was created when Tony saw the expression, and though he would normally have corrected her hidden hand, the moment was right to trip the shutter. Normally when we have a woman fold her arms we expose all the hands and spread the fingers, but to get this impression we would not do so.

There is motion and attitude in the image, all created by the folded arms and gentle yet strong body language. Tony may have requested the pose, or it might have resulted from something he said. Either method works.

The portrait was made using slightly overcast sunlight from camera right, which created a very pleasant lighting pattern. Recognizing lighting opportunities is a skill we need to learn and practice.

6. Rick Ferro

Rick Ferro owns and operates Signature Studio in Jacksonville, Florida, with Deborah Lynn Ferro. He is regarded as one of the leading wedding photographers in the United States and has been awarded First Place in WPPI print competition. Rick is the author of *Wedding Photography* (3rd ed.) and is coauthor of *Wedding Photography with Adobe® Photoshop®* (with Deborah Lynn Ferro), both from Amherst Media. He has received his Certified Professional Photographer degree from PPA and has been awarded an Accolade of Photographic Mastery from WPPI. Rick and Deborah run the Ferro Photography School.

Plate 62 is a beautiful bridal portrait. Her expression is one of serenity and one that says so much about the woman, relaxed yet elegant, confident, and self-assured. This is shown by the relatively perpendicular pose of her body.

The lighting is exquisite with a 3:1 ratio that lights her face perfectly in a three-quarter view to the camera. The technique of posing the subject away from the main light is one I advocate for bridal portraits to show the beauty of the gown and flatter the bustline.

The main light, a large softbox, was placed at 50 degrees from the camera, sweeping the light across the subject to model her features and figure. A fill light was used close to the camera to complete the beautiful sculpting.

In plate 63, Rick chose to show only half the face, placing it in the right-hand third of the composition. The technique draws us to the eye of the subject because the space at the left has no distracting objects or background elements. The lighting was simple; a softbox was placed near camera left and high enough to create the gentle shadow below her nose indicated by the catchlight at 1 o'clock. The highlight on her cheek and chin was created

by light reflected from her clothing. Remember that by taking advantage of light reflected from the garments of our subjects, we may eliminate the need for additional lights or reflectors.

The black & white portrait in plate 64 shows a young woman leaning over a chair arm with her hands clasping it. With her body in this position, a diagonal line was created from the from top right to the lower left of the frame. Her head was slightly straightened so that it is not at a right angle to her shoulders. This gives us the im-

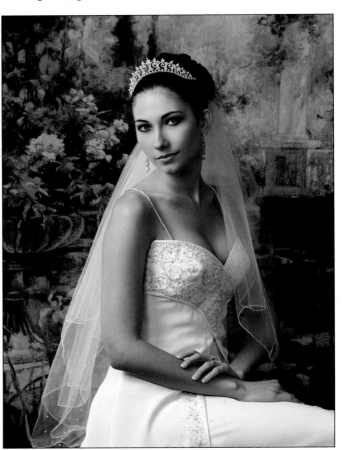

PLATE 62

PLATE 63

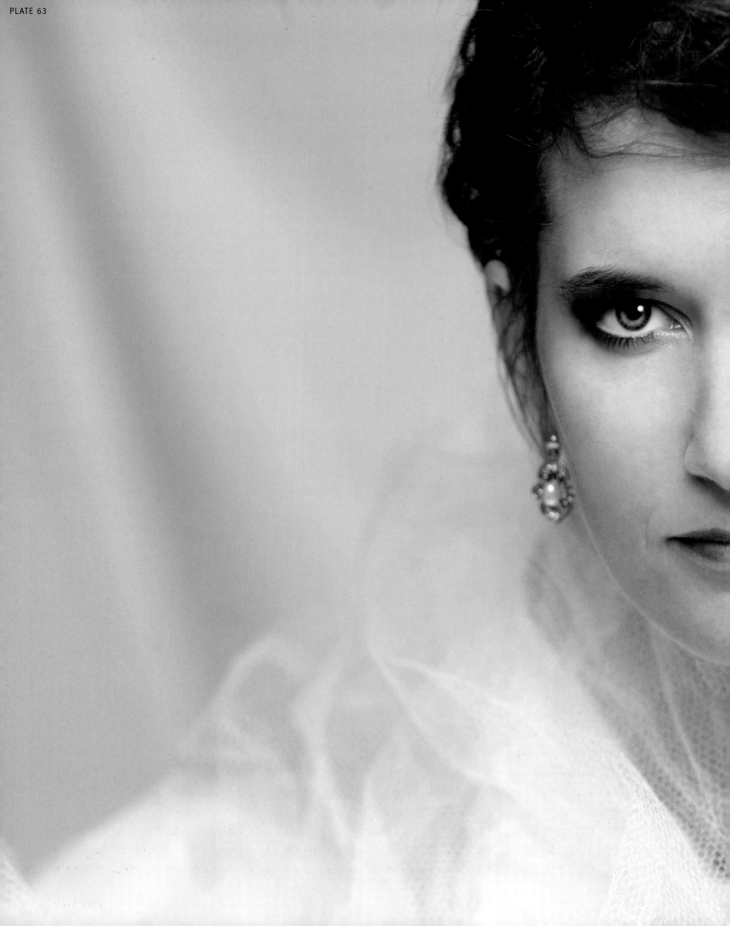

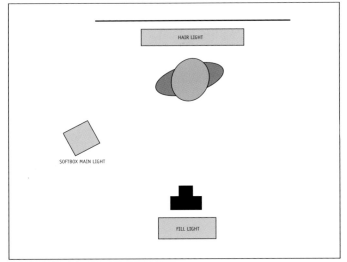

PLATE 64 (TOP); DIAGRAM 9 (ABOVE)

PLATE 65 (TOP); DIAGRAM 10 (ABOVE)

pression that she was actively involved in the creation of the image. Head angles will always create either interest or disinterest. The natural expression on her face is very attractive and suits the casual pose. Notice, too, how her hands are casually resting on the chair back—it's a pose you can imagine her sitting in every day.

The diffuse lighting created a soft but lively 3:1 ratio. The main light was a softbox placed at 45 degrees from both camera and subject. A fill light behind and above the camera was set to one stop less than the main light. A hair light was placed above and slightly behind the woman's head; its placement is indicated by the light on her left shoulder. See diagram 9.

In the black & white portrait shown in plate 65, the bride was posed square to the camera with her hands relaxed in her lap or holding a bouquet, which is not shown

PLATE 66 (TOP); PLATE 67 (BOTTOM)

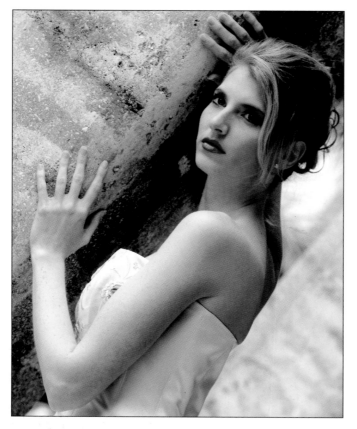

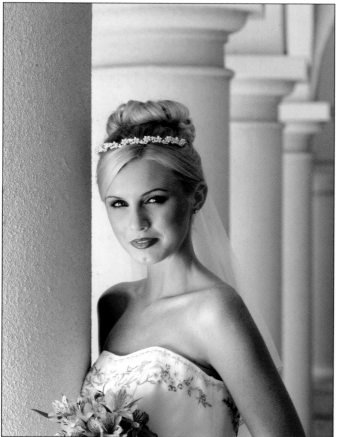

in the image. What makes this portrait successful and dramatic is how her head is slightly tilted to our left and slightly turned away to present a three-quarter face view—hence the expression evoked by her presentation to the camera.

The main light was window light 25 degrees from the subject and 70 degrees off the camera. (See diagram 10.) This created a 4:1 ratio from highlight to shadow. The angle of light was important because it illuminated the veil behind her head. Were she farther back and closer to the wall the light would not have illuminated the veil.

This position also caused the extended lighting ratio. The light produced strong modeling, which in black & white almost eliminates the edge of her right cheek, but there is enough there to make this a very striking image of a beautiful bride. We can see evidence of great communication between the photographer and subject by her expression.

Plate 66 is another natural-light portrait. With his subject squeezed between two walls, she was bound to be in a vertical pose, so Rick tilted the camera to create a more dynamic portrait.

Notice the unusual hand pose Rick used here. The bride's fingers are spread and the back of her left hand faces the camera. What makes this work is the upper hand. Placed at her forehead, the hands are visually connected, unifying this feminine composition.

By having her head inside the line of the wall Rick created the 3:1 lighting ratio. This also caused the eyes to be in deeper shadow, drawing us into the portrait. Had she been outside the line of the wall the ratio would have been shorter.

In plate 67, used on the cover of one of Rick's books, the natural beauty of the woman and the compelling lighting on her face are what make the shot a success. The 4:1 lighting ratio Rick achieved in this daylight portrait is as beautiful as any similar effect we might create in the studio; it's a great example of what's possible with natural light.

The pose is familiar—a three-quarter face view and a shoulder angle a little over 50 degrees off camera. The subject is in just the right position with the pillar. It's perfect.

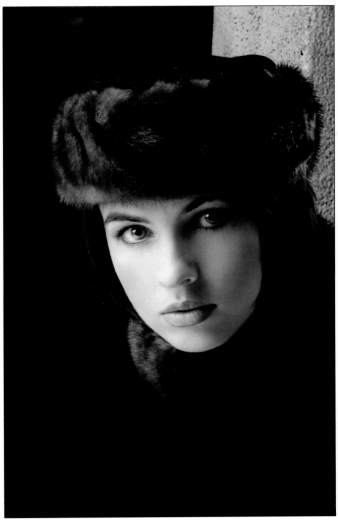

PLATE 68

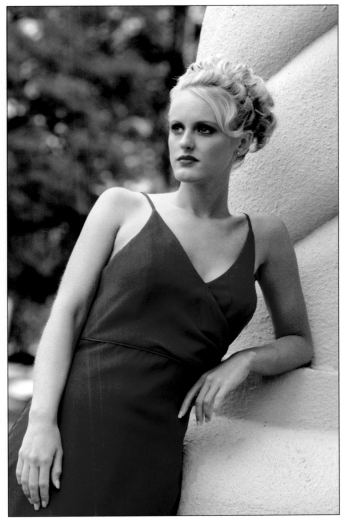

PLATE 69

Plate 68 is an excellent example of a low-key portrait. The lighting was perfectly executed to match the expression. Note the butterfly-shaped shadow below the subject's nose.

You can follow the contour of her features from her left eyebrow, down her nose, upper lip, and chin—all in as perfect a line as possible. This was due to the angle of her head, which was tilted about 5 degrees to our left by having her lean gently in that direction. Her head position also rendered the desired lighting pattern. A little fill light from our right reduced the ratio on her left cheek and provided a little kicker at the edge of her cheek, providing extra depth. This setup created a beautiful light in her eyes.

Plate 69 is a natural, casual pose shot from a relatively low angle. Her hands were posed in a passive presentation; this is something women are able to do that most men are not. She rested her weight on her left foot and relaxed her right leg in order to casually rest her arm on the wall. The low angle of view made this portrait work. The idea behind such a view is to create a dynamic that would be missing if the camera angle were more conventional for female portraiture.

The natural light created a pleasant 3:1 ratio that nicely sculpted her face.

Plate 70 shows another example of using space on the side of the frame to draw the viewer's attention to the face. Note that the subject's head was very slightly tilted to our left so as not to appear static. Her hands were perfectly posed, and her chin just touched, rather than rested upon, her fingers. This is important because if her chin had rested on her fingers, her expression would be different and the pose might have impacted the contour of her chin.

To obtain this pose the elbows must be placed at just the right height so that the subject does not drop her chin onto her hands or push her head upward.

The lighting created a tight loop pattern around her nose, and the gentle ratio shows her skin tones beautifully. A softbox, with two diffusing panels, was the main light, and a fill light was placed behind the camera at one stop less than the main light. The result was a lighting ratio of almost 3:1.

Plate 71 shows an interesting combination of conflicting angles and lighting patterns. But as a composition, it is intriguing. The image is photojournalistic in nature. The posing of the hands breaks several rules but creates some interesting lines and shadows. Both hands are in a pose that we may well see a female naturally take. They also support the subject's inquisitive expression. The soft and somewhat flat light allows the deep shadows caused by her hands and arms to create interesting patterns within the image, which was further enhanced by the specular light spots on her face.

This portrait suggests that when we are able to get a spontaneous pose we should not be overly meticulous in refining it, as we may lose the spontaneity and natural expression. Remember that women react differently than

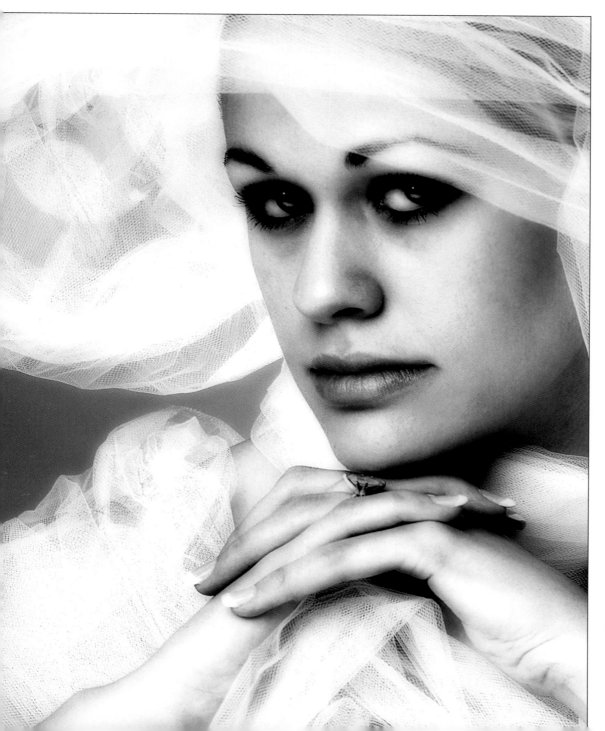

PLATE 70

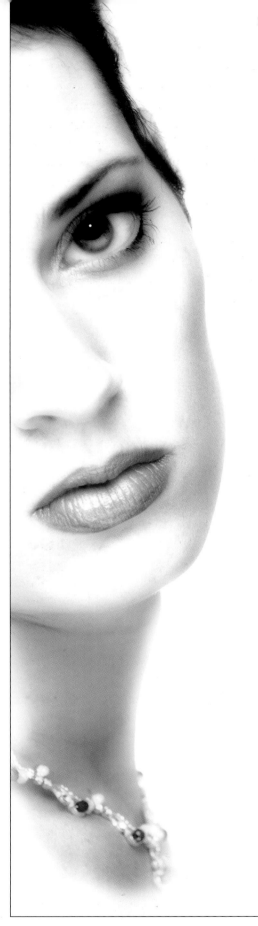

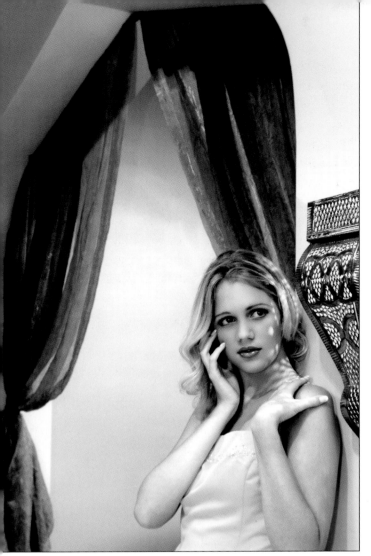

PLATE 71 (ABOVE); PLATE 72 (RIGHT)

men in similar circumstances, and sometimes capturing what spontaneously appears in front of the camera is more important than tweaking.

Plate 72 once again shows the split face technique. In this high-key image Rick had the subject's head tipped to the near shoulder in the traditional but less used female submissive head position. She was positioned profile to the camera so that her head pose was accentuated and rendered in a delicately soft light. The portrait was composed so that the cropping at the left followed the contours of the right side of her nose.

The main light was placed a little to camera left a bit higher than the subject. This created a shadowed line that emphasized the shape of her left cheek.

7. Jeff and Kathleen Hawkins

Together, Jeff and Kathleen Hawkins have written six books (all from Amherst Media) on a variety of photography topics. Both Jeff and Kathleen are award-winning photographers and are frequent speakers to professional groups, including WPPI and PPA. Jeff is a PPA Certified Professional Photographer and also holds the PPA Craftsman degree. He has also had prints accepted in the PPA Loan Collection. Jeff has also served on the PPA Digital Advisory Committee. Kathleen has three times been a first-place winner of the PPA AN-NE award for marketing excellence.

When photographing women environmentally, Jeff and Kathleen's goal is to take a fashion approach to the images. "We want them to have fun and be themselves while we unobtrusively capture their images," says Kathleen. She goes on to say, "We coach the clients along but never touch or physically pose a subject." Jeff and Kathleen believe knowing and understanding their clients is imperative in order to capture their personality.

Plate 73 is a very natural portrait captured by available light. The soft, almost flat daylight created what might be termed "pools of water" in the eyes. Note that this type of lighting produced numerous reflections in the eyes, as opposed to a specific catchlight that would be seen were strobes used to create the portrait.

Note that the subject's body was turned almost 45 degrees to our left and her head was turned to look straight at us. The hand pose is typically female.

Plate 74 has snap and charm. The cropping is unusual but it serves to enhance the pose, an almost straight-on frontal view.

Her head was very slightly turned to our right and the shadow that rimmed and accentuated her face is both unusual and effective. It is the reverse of what we term rim

PLATE 73 (FACING PAGE); PLATE 74 (ABOVE)

lighting, which is the effect of directing light from a position behind the subject so that it highlights just the edge of the subject. This shadowing effect may be achieved outdoors or in the studio by directing the light from the right of the subject and lighting the background with natural light or strobe and avoiding reflected light on the far side of the face.

Plate 75 is an extreme high-key image of a pregnant woman posed on the floor with her head nearest the camera. This is a very unusual treatment of this type of subject. The subject's elevated legs accentuate her femininity; this is an element that is often lost in maternity portraiture. With an emphasis on the hair and limbs, the portrait

PLATE 75

PLATE 76

concept glamorizes pregnancy instead of focusing on the enlarged belly. Gently resting her hands on her unborn child, the pose draws us to her rounded belly.

The crossing of her ankles is most important; we should always seek to create a tapered look when photographing our female subjects. This is well done and the legs look glamorous, which is important to her and the father of her child.

There is lots of light in this image, primarily from our left, but the basic concept of delicacy has been well delivered as all the lines that are visible create a little magic.

Plate 76 is an example of broad lighting. The subject was turned away from the light source, and because her right eye is presented in shadow, we are drawn to her left eye. The bright walls around her provided enough reflected light to reduce the ratio to less than 3:1. The deeper shadows between her arm and neck provide relief from the brighter left-side area of the composition, which provides a leading line to her face.

The pose is a natural one that we could achieve by simply requesting that she lean against the wall and rest her elbow and hand on the wall.

The camera was tilted to create a triangular composition that fills the right side of the image. In a composition like this, we tend to gaze across the empty space in search of the point of focus.

To produce the image in plate 77, a Photogenic DR 1250 with a Larson softbox was used as a main light and was positioned in line with the subject's body (90 degrees off camera) and at an elevated angle. This ensured that the direction of the light produced a minimum of harsh shadows (except between the subject and the pillows, where they would have been impossible to eliminate them in this situation). A silver reflector placed at the camera position added a little fill light to ensure a lighting ratio of less than 3:1. This setup provided just enough depth at the top of her bodice to accentuate her figure.

The position of her arms is one that comes naturally to women. Her right hand has a nice sweep around to her head, and this helps draw us into the portrait. Her left arm is relaxed by her side, and her hand rests on her stomach. The vertical line presented by her left arm is fine in this casual portrait. For a more traditional pose, we would have moved her left arm a little toward her bust to create a diagonal leading line to her face.

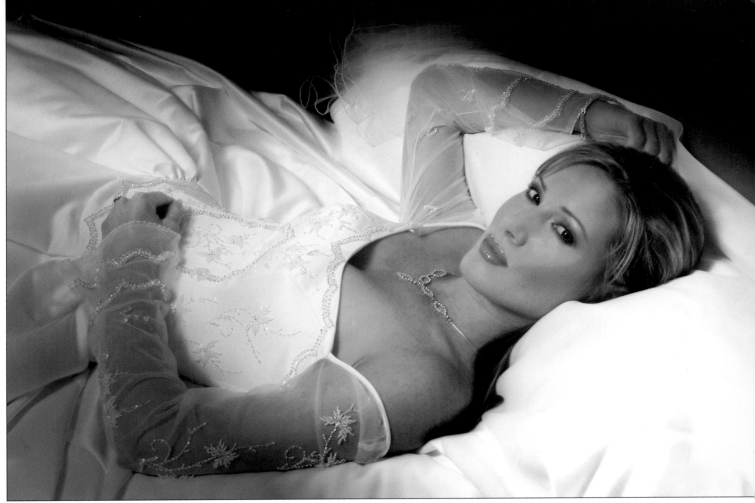

PLATE 77 (ABOVE); PLATE 78 (RIGHT)

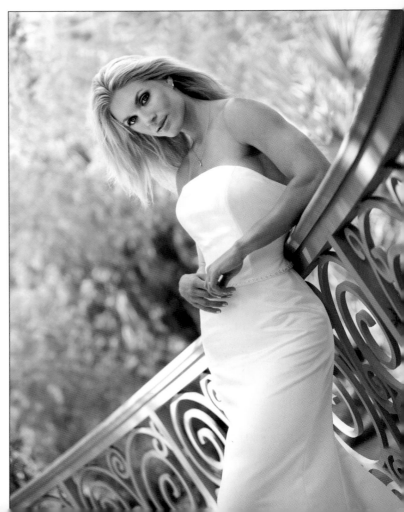

Plate 78 is a delightfully feminine, dynamic portrait. There are great yet gentle curves throughout the image. The tilted camera and low angle from which the image was captured provided a very flattering impression. The sweeping curved line of the rail created a great diagonal line from the bottom-left corner to the top-right corner. The camera angle also caused the subject to appear to lean a little to our left, and this created the gentle S curve that starts at her left knee, runs around her near hip and around her arm to her head. The way her hair falls adds to the sex appeal in this portrait.

The subject placed her weight on her right foot and relaxed her left leg, which is beautifully broken at the knee. She placed her left arm on the rail without distorting the forearm and rested her right arm against her right hip. Even without this great camera angle this would be an excellent portrait.

Daylight alone was used to create this beautiful 3:1 ratio. Her position at the rail was carefully chosen. You

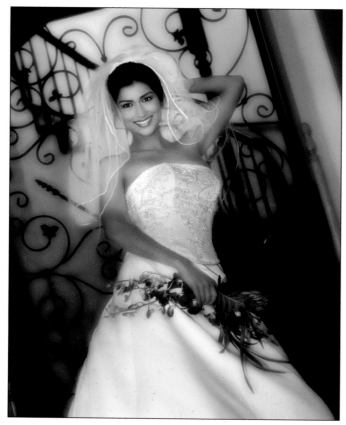

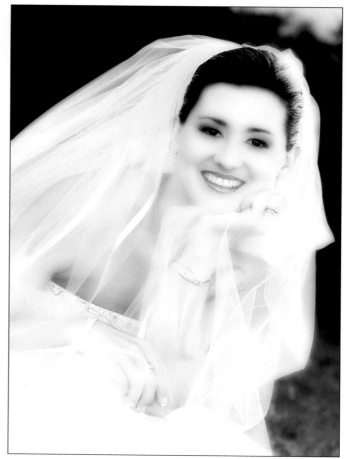

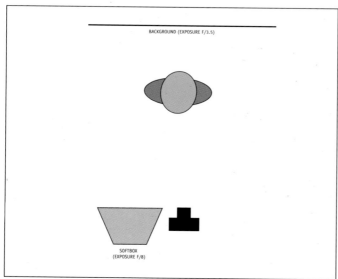

PLATE 79 (TOP); DIAGRAM 11 (ABOVE)

PLATE 80

can see that there is direct but soft light on her face, yet the light on the rest of her is soft and relatively flat. She was positioned just to the right of an area that was in more direct sunlight, which would have nullified this sensual lighting pattern.

Plate 79 is yet another spontaneous-looking portrait that might have been the result of asking the bride to ex-

press herself. We are able to see that the woman was moving in a gentle, circular motion, using her arms and expressing her freedom. It is a very effective technique with which to get free-flowing expressions from our subjects.

The image was captured in a relatively close location, and a softbox was placed a little to the left of the camera. The white balance on the digital camera was set to flash and the shutter was dragged to record the background, which was illuminated by tungsten light. (See diagram 11.) As this image appears to have been created with a handheld camera, we can assume that a shutter speed no slower than $1/30$ was used to eliminate the possibility of blur due to camera shake or subject movement.

There is a nice balance in the color rendition, with the warm background complementing the subject's skin tones.

Plate 80 is a portrait that is quite different from those previously discussed, because it shows a slightly overexposed high-key subject against a low-key background. The image has a kind of fantasy feel because of the over-

exposure, which created a delicate rendering of her face and shows just a hint of her gown and arms. The effect is to draw focus to her eyes. Her dark hair helps to frame her face against the pure white gown and veil.

The subject was seated with her left elbow on her left knee and her right hand in her lap near the left elbow. Her chin rested on the palm of her hand and very slightly lifted her head. Some have described this approach as one that emphasizes innocence, while others have described it as alluring because we are drawn into the image in order to see the detail.

A Canon 580EX Speedlight on camera provided the lighting.

Plate 81 was created using a Larson softbox at the right of the camera with a silver reflector to camera left. There is a lighting ratio of a little less than 3:1. The lighting effect is soft and feminine and matches the pensive head pose and expression.

The posing of the arms is very natural, and the comfort the subject projects (especially when paired with the higher camera angle used here) helped to create a delightful portrait with a different perspective.

The mood of the portrait is restful, and the camera does not appear to have intruded on the subject's personal space, as is the case in most close-up portraits. This approach is to be commended, as it shows the subject in a zone that excludes us and reflects a special charm that is unique to her. Jeff and Kathleen used a Sky High background for this portrait.

Plate 82 is another captivating portrait. Window light was used to create delightful reflections in her eyes that draw us closer. Cropping tight, and especially clipping a little from the right side, also draws attention to the eyes.

Note that the subject's eyes are not on a level plane but are slightly tilted to create a dynamic feel and prevent a staid expression. When the eyes are presented on a level plane they may appear a little boring, regardless of how beautiful they may be. It's best to tilt the face slightly unless there is a special purpose for showing the eyes in a level presentation.

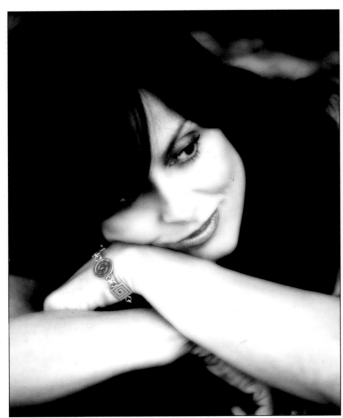

PLATE 81

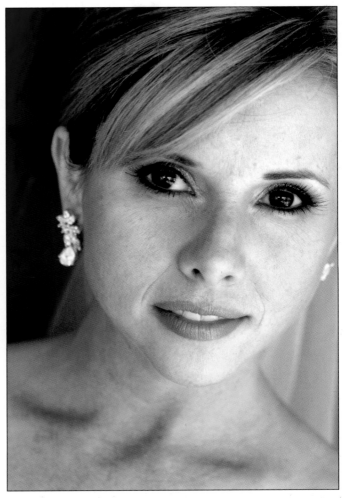

PLATE 82

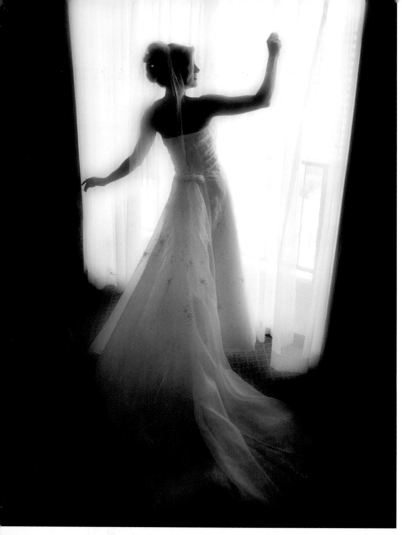

Plate 83 shows the elegance of female motion. Note the sweeping line that runs from the bottom of the subject's gown to her shoulders and then breaks a little with her head slightly turned to our right. The expressive posing of her arms is natural and very feminine. The sweep of the gown at the bottom right adds a little extra curve.

The lighting here is pure window light, which came from in front of her, creating a romantic diffusion. This required accurate exposure; otherwise, the edges of the arms and head would have been washed out instead of showing facial detail. The image shows that backlighting can be very effective and produce very subtle tones and shaping.

Plate 84 is another great expressive female image. The contrast produced by direct sunlight emphasizes the wonderful feeling of sensual feminine motion. In this example, the 6:1 lighting ratio works to great advantage. Again, it is important to nail the exposure so that we see the detail in the gown. The tilt of the camera added to the dynamic quality of the image. The flow of her veil added great lines and interest that furthers the femininity of the portrait.

PLATE 83 (LEFT); PLATE 84(BELOW)

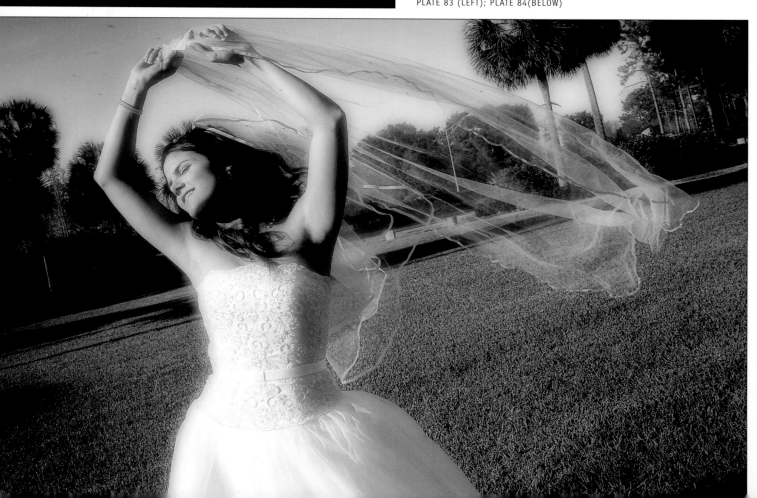

8. Mark Laurie

Mark Laurie is a celebrated Canadian photographer who has achieved international recognition. Mark has a Fellowship with Britain's SWPP, a Master of Photographic Arts, and a Service of Photographic Arts. His work is displayed at the Epcot Center, Hungarian National Cultural Center, the Calgary Stampede, and in London's International Hall of Fame. He has numerous national and international awards, including SWPP's Overseas Photographer of the Year.

Mark's specialty is photographing women. He believes providing his clients with an unforgettable experience is of the utmost importance and says, "With great posing and lighting, every woman can look breathtaking."

In plate 85, Mark shows a beautiful image that reflects the young woman's innocence and charm. The expression is friendly and soft, and the lighting is at a little less than a 3:1 ratio, which is why it presents an open style of portrait. The catchlights in the subject's eyes indicate that the main light was positioned at camera left at about 45 degrees off camera and subject. The second catchlight resulted from the fill light behind the camera. (See diagram 12.) We can also see the hair-light exposure matches the overall exposure. The use of the black background makes the image jump off the page.

The lens perspective is an important element in the image. The camera was positioned level with the top of the subject's head. The lens was tilted downward so the client looked up at the camera. Mark also used the golden rule of having her forehead a little in front of the subject's chin, causing her to open her eyes wide in order to stay in contact with the camera. Also note that her head is slightly tilted to our left and not on a vertical plane.

PLATE 85 (TOP); DIAGRAM 12 (RIGHT)

When photographing men we may not want to use the same technique.

Plate 86 shows a young woman laying on her stomach with her arms folded and her cheek resting on her hands. Note how the placement of her hair directs our eye to the face. By covering her left eye with her hair, Mark was able to draw the viewer's gaze to the subject's right eye, which is looking away from the camera.

Mark used a relatively soft light just above the subject's head and to our right to create a tight loop lighting pattern below her nose. Diffusion was used to create a gentle transition from the base of the portrait to the point of focus.

Creating a high-key, black & white portrait with a hint of color is a popular technique.

The portrait in plate 87 illustrates the "direct portrait" style where the subject looks directly at the camera in a vertical head position. The subject's forehead was a little in front of her chin, so she was forced to more fully open her eyes to look at the camera, which was positioned a little above her head and tilted downward.

The vertical pose worked well with this subject's expression. Her hands supported the head pose. Had her hands not been gloved in white (to match her coat), they would have distracted from the focal point of the image, the eyes. Mark clipped a little of the subject's hair at the top of the frame; this draws our gaze to the subject's face. While this can be an effective technique, it should be used with discretion.

The lighting produced a 3:1 ratio, but the high camera angle prevents us from seeing the fairly tight loop lighting pattern below her nose. The choice of all white attire allows the head to be seen in relief against a white background.

Plate 88 is of special interest, as Mark has broken some of the rules of traditional posing. First, he allowed the subject's left hand to be hidden behind her right arm. Second, her right foot appears isolated at the bottom of the dress. Yet, the image has a natural, spontaneous look that suits the young woman—and the fact that she is barefoot, a nice contrast with the formal gown, suggests an informality that makes the portrait work.

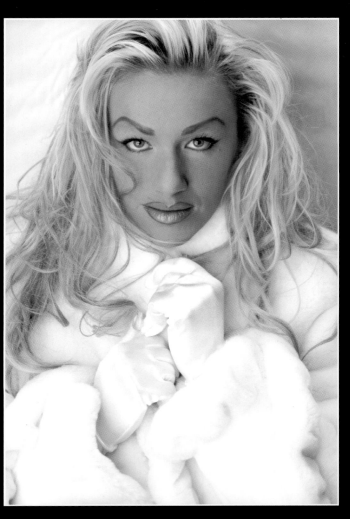

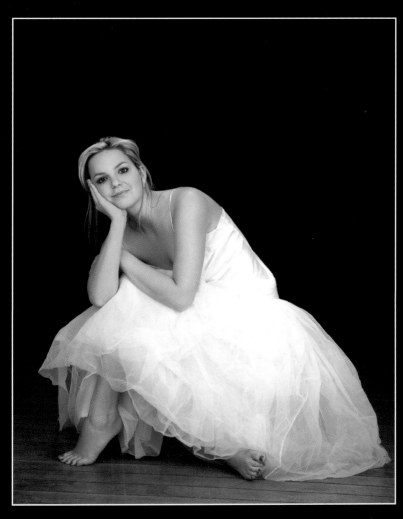

PLATE 87 (TOP LEFT)

PLATE 88 (TOP RIGHT)

PLATE 89 (RIGHT)

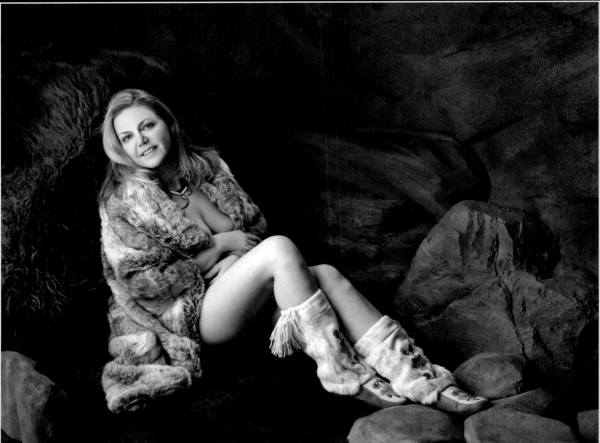

The relatively soft and flat lighting pattern rendered beautiful skin tones against a black background. Mark used two large softboxes to illuminate the subject. One was placed at approximately 30 degrees off camera and one high and behind the camera, both at the same f-stop. The large softboxes produced the beautiful skin tones; the larger the light source, the softer the light.

The portrait in plate 89 is an example of how daring Mark is when photographing his female subjects. The protective quality of the pose suggests the subject is naked underneath the fur coat. She is somewhat huddled beneath the coat with her arms clasped at her midriff and her right leg pulled toward her center. The image is decidedly feminine and quite natural.

The lighting was from a softbox at about 35 degrees off camera to our left. If Mark used fill light it is barely discernable, hence the 3:1 light ratio from highlight to shadow.

One of Mark's specialties is boudoir portraiture, and plate 90 is an example of this style.

The softness of the light in this image was produced with a large softbox, which produced enough light to cover her figure. There is a hint of fill light over the position of the camera.

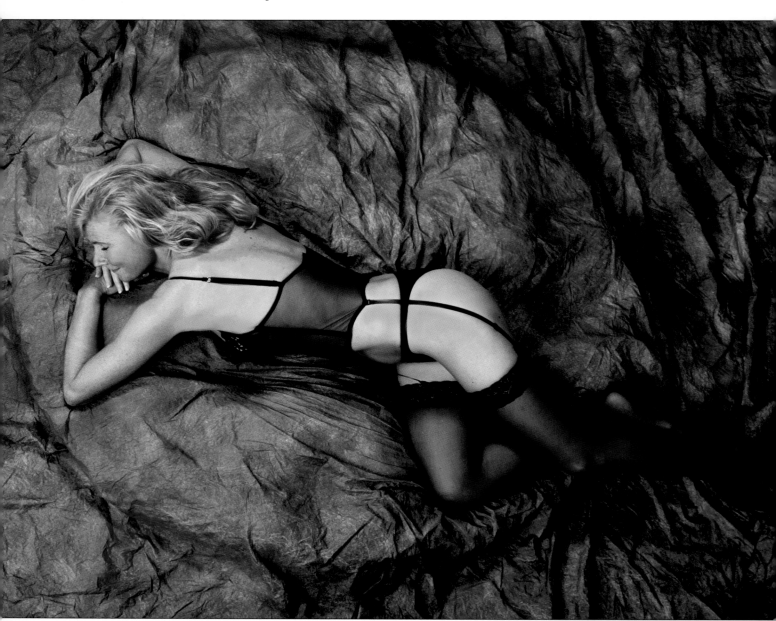

PLATE 90

PLATE 91

PLATE 92

PLATE 93

The subject's right leg was pulled upward to break the line that runs along the length of her body. This created a provocative and sensual pose. We can see that she is not totally on her stomach but slightly turned toward us to show a more shapely form.

The subject's pose in the high-key image in plate 91 is the reverse of that shown in plate 90. The subject's left leg was brought over her right and bent at the knee, making the right leg the long line in the pose. Mark had his subject turn to look directly look at the camera with her beautiful hair arranged around her face and over her upper chest.

Plate 92 shows the subject in another daring pose. Working on a reflective surface, she was posed below the camera position and smiled up provocatively toward the lens. Her arms were spread wide, and the placement of the dress over her right knee draws our eye to her long

left leg. In an image that is otherwise quite monotone, it is the skin tones of her upper body and legs that causes us to scan the entire portrait.

To light the high-key image, Mark placed a large softbox at a 45-degree angle between the subject and camera. A second softbox was placed behind the camera and provided fill light.

Plate 93 is a fashion-type portrait with the woman shown in a profile pose. By asking the subject to gently place her left hand on the side of her head, Mark was able to capture a sense of motion in the portrait—and add some nice diagonals. The very slight turn of her hips toward the camera shows a little width of the pelvis and accentuates the sex appeal.

As seen here, having a subject resting on her elbow will usually create vertical and horizontal lines, rather than diagonals. If you were creating a more traditional

PLATE 94

type of portrait, this is something you might avoid. In a fashion-style portrait, however, this is a nonissue.

The portrait was made with daylight and enough fill to create excellent skin tones and an overall delicate rendering of a beautiful woman.

In plate 94 we again have a subject resting on an arm in a very natural pose. The pose has us follow a line from her face along her figure to her knee and back again as she presents a profile view. The arm is in a very natural position and also has us reviewing the entire composition from end to end and back again.

The main light was positioned in front of her and about 24 inches above her head. Another light was behind her at approximately the same power as the main light. This created a three-dimensional lighting pattern that highlighted the front of her figure and the back of her arm and shoulder. When we use this technique we rarely need to use a fill light at the camera unless the light is too specular.

In plate 95, Mark continues to use natural posing techniques. The woman was seated and hugged her knees, and her right hand gripped her left forearm. We see this pose in everyday situations, so it is perfectly acceptable and needs no adjustments if we are seeking natural impressions.

Her bare feet added a nice feminine touch to the portrait and enhanced the natural look of the portrait.

The main light was a large softbox at about 50 degrees off the camera. A fill light at ½ the power of the main light was added behind the camera to reduce the ratio to 3:1.

The portrait of four women in plate 96 shows each subject in relief against a black background.

To light the image, Mark placed a large softbox at about 40 degrees off camera and added a fill light behind the camera. A hair light was positioned almost directly above the subjects to perfectly illuminate their hair. Because the light was soft, we can still see some minimal detail in the black sweaters. A harder light would have caused the sweaters to disappear completely and merge with the background.

The ratio is less than the standard 3:1 and is a constant in most of Mark's work, as he prefers the open style of lighting to bring out the best in skin tones. This technique of using ultrasoft lighting is close to glamour style

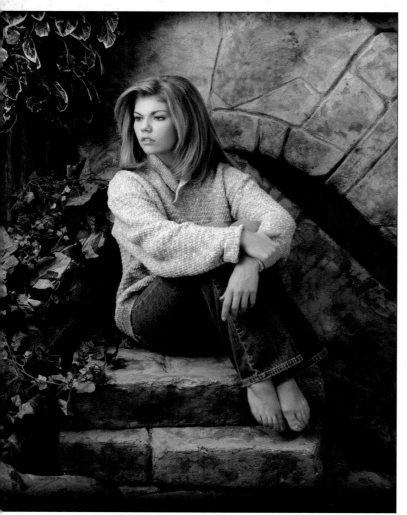

PLATE 95

PLATE 96

lighting, which eliminates almost all skin imperfections and reduces or eliminates strong feature lines.

The composition is perfect in that we are able to clearly see each subject, and no head is directly above or below another. Note that each head is very slightly tilted so that the eyes look interested. This also allowed each of the subjects to present a slightly different expression.

In plate 97 an S curve is presented from the subject's right foot and up through her jacket and to her head, which is slightly tipped to our left. The position of her arms presents a nice line from her right hip and around to her extended left hand, which rests on her knee. Placing her left foot on a prop allowed the knee to be comfortable and made it possible for her to rest her hand on

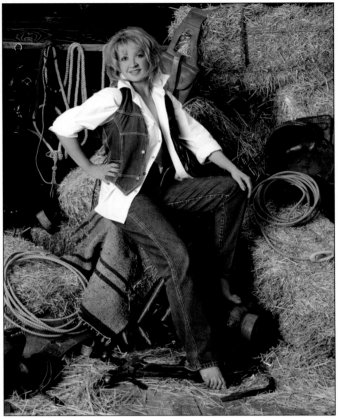

PLATE 97

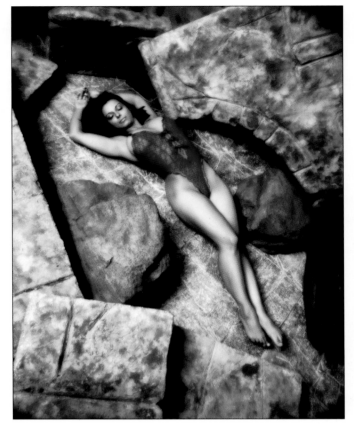

PLATE 98

her knee. This is an attractive pose and composition, as it uses the blue jeans and jacket to strengthen the curve.

A large softbox, which is required to evenly light a full-length portrait, served as the main light. It was placed at 45 degrees off camera and subject. A fill light was employed to hold the ratio at 3:1.

Plate 98 is another example of the Mark Laurie style of glamour portraiture. The pose has great sensual curves. The position of her arms widens the tapered lines from her waist up through her bust, emphasizing an attractive figure. Because Mark had the subject pull her right knee up a little, the tapered line from her hips to her feet is accentuated and there is a gentle curve that follows from feet to her arms.

By observing the shadows we are able to see that a large softbox positioned high and a little to the left of the camera produced the light in the image.

Plate 99 is dazzling. The use of strong patterns in the woman's attire and the matching fabric she is laying on challenges us to find the lines in her pose, but they are certainly there. We are able to follow the lines of her figure by noting the stronger whites in her dress.

PLATE 99

Dave Newman needs little introduction to those who have been to his seminars and presentations. Those of us in the industry are widely familiar with his artistry and technical expertise. Dave is a PPA Master Photographer and a Fellow of the SWPP. He has accumulated over 350 PPA merit prints, has twice been named the SWPP Overseas Photographer of the Year, and has received the SWPP Lifetime Achievement Award in Recognition of Dedication and Service to the Industry. He has also lectured in numerous countries around the world.

Plate 100 is a classic example of elegant portraiture. A four-light setup was used. A main light was placed to camera right, and a hair light placed a little behind her not only illuminated her hair but also provided a little kicker light on her right arm and shoulder. A fill light balanced the exposure to ensure that no indelicate shadows fell onto her figure. A fourth light illuminated the background to keep it in the low-key range. Note that the fourth light had adequate spread to evenly light all of the background. In our diagram we show this light behind the subject but it could, with good control, be placed to one side.

The main light, placed at about 65 degrees off camera and 20 degrees off the subject, produced a perfect lighting pattern on her face with a little over a 3:1 ratio. The fill light behind the camera was at $\frac{1}{4}$ an f-stop less than the main light, while the hair light almost matched the main light, hence the beautiful rendering of her figure. See diagram 13.

The pose is elegant. The position of her arms creates a gentle diagonal that directs us to her head, which is slightly tilted to our right and breaks away from the hor-

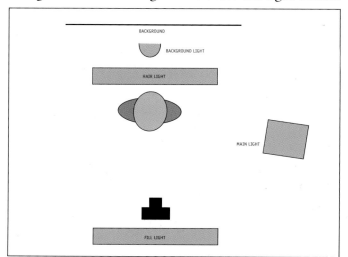

PLATE 100 (RIGHT); DIAGRAM 13 (ABOVE)

PLATE 101 (TOP); DIAGRAM 14 (ABOVE)

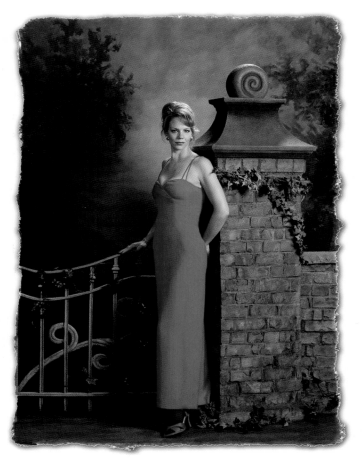

PLATE 102

izontal line of her shoulders. The pose also has a triangular shape created by the position of her arms. Note too that her fingers are not clasping the back of the chair, but instead are gently resting on the chair back.

Plate 101 captures a delightful sense of feminine motion. These images are all about timing in order to catch just the right moment. Dave waited for the subject to swirl her skirt at speed and captured the image with the subject at a three-quarter face position. With the light at right angles to the camera and in a profile direction to the subject, this timing was critical. See diagram 14.

Also critical was the shutter speed, which had to be fast enough to freeze her expression but slow enough to create a blur for the full sense of motion in her gown.

The speed of the moving gown would be perhaps three times that of her head and upper body movement. Typically the shutter speed would be $\frac{1}{60}$ second.

Plate 102 is a statuesque full-length portrait. Though the subject stood relatively straight, her left knee was bent a little with her foot taking none of her body weight, which was all on her right foot. This created a break at the knee that provided a very gentle curve in the line from her feet to her shoulders. Her head was posed in the "proud" position, virtually full face to the camera and very slightly tipped toward the lens.

Her arms are in a classical pose that elegant women are likely to assume, with one hand placed at her back. This caused the arm to bend in a very feminine curved line. Her right hand rested gently on the gate at hip level. The very slight turn of her hips toward the camera produced gentle curves throughout the pose.

With the subject's position in the composition, Dave had to take extra care to ensure that the lighting setup did not cause the wall to appear burned out. To meet this

need, the main light was placed about 45 degrees to camera right and slightly feathered across the subject. A hair light was placed above and very slightly behind her head.

The profile portrait in plate 103 is a little different from those seen previously. Dave was slightly to the left of her pose, so her shoulder served as the base of the composition. This allowed him to keep the shoulder less illuminated than the focus of his portrait, her face, which was illuminated at a 3:1 ratio. To achieve this ratio, the light needed to be almost directly in front of her.

Note that the head pose creates a slight V-shaped pattern between her shoulder and chin. This is acceptable because she is looking upward. Note that she is focused on an object that is not directly in front of her but slightly to her right. This allows us to see her beautiful eyes.

PLATE 103 (BELOW); PLATE 104 (RIGHT)

The profile portrait Dave created in plate 104 is a classical example of the profile technique. The subject was photographed looking slightly upward and focused on

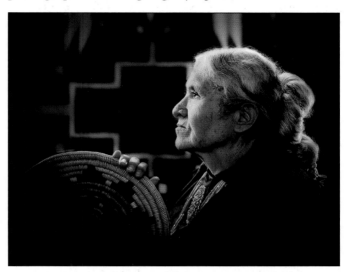

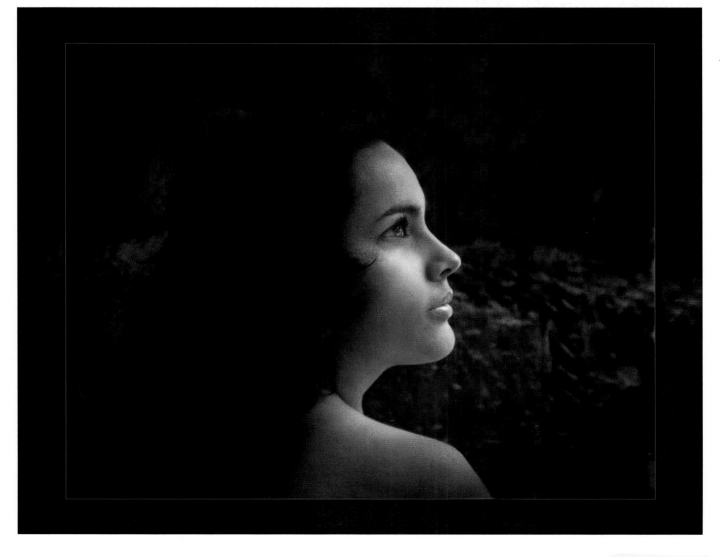

something a little to her left so we could clearly see her eyes. The placement of her hand on the back of the chair created additional interest.

The main light, a softbox, was placed a little behind her to produce a 3½:1 ratio that more strongly defines the features. A hair light was placed very slightly behind her, not quite over her head, so that it illuminated the hair but did not spill over the camera side of the subject. A fill light from behind the camera at ¼ the exposure of the main light opened up the side of the face enough to create interest without reducing the feeling of depth.

In plate 105, Dave had the subject rest on her elbows with her left hand gently clasped to her neck. You will see three diagonal lines within the portrait. The most important is the one created by tipping her head; this draws us to the focus of the portrait. The second is her left arm, which guides us to her face. The third, formed by her right arm, takes our gaze from the bottom-left corner of the frame and up to her face.

A softbox was the main light. It was placed to camera left, 45 degrees off camera and subject. A fill light from behind the camera was set to match the exposure of the main light. This created a soft wraparound lighting pattern, beautifully sculpting her face.

The high-key portrait in plate 106 shows the woman in a three-quarter view. Her face is turned to the camera so we can appreciate her happy expression. Her pose is casual and typical of a younger female. The slightly spread position of her feet is key, as it allows us to see both hands, tucked into her pockets. Her bare feet add to the femininity as does the fact that her head is tipped slightly toward the near shoulder. This helps create a slight S curve. It's another example of making a basic masculine pose work beautifully with a female.

The lighting was provided by a standard high-key setup with the main light at a little more than 45 degrees off the subject's right for a 3:1 ratio.

Plate 107 is a portrait made with a different two-light setup. The main light was a softbox at 30 degrees to camera left. This produced a soft light on her face with a gen-

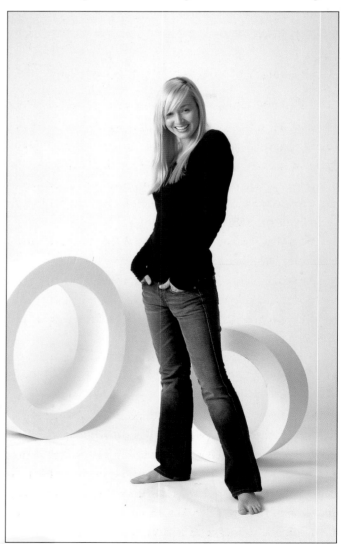

PLATE 106

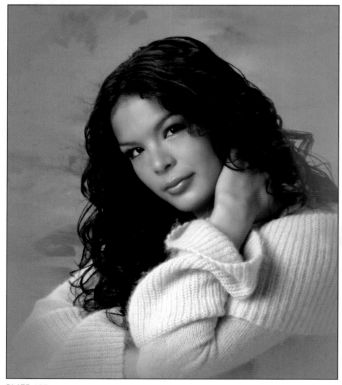

PLATE 105

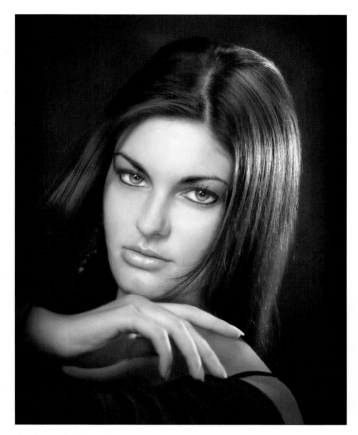

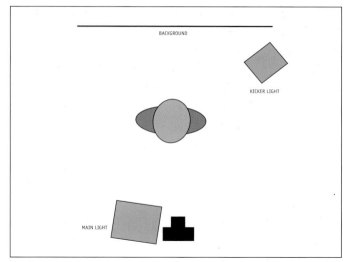

PLATE 107 (LEFT); DIAGRAM 15 (ABOVE)

tle loop below her nose. A second light placed at camera right and on the same plane as the subject provided highlights in her hair and fingers. The second light was a little more specular than the main light and acted like a kicker, adding sparkle to the image without taking us away from the face. See diagram 15.

Long slender fingers are essential for this hand pose. Note that Dave had the fingers separated so that they did not present a mass of skin tones below the face. To create the pose, the subject positioned her arms on a posing table so that the right arm had a base and the subject did not have to hold her hand in space.

In plate 108 the pose produced three connected diagonal lines. The key diagonal is that which runs from the bottom right of the frame, through the subject's left shoulder, and through her neck and head. The second is that of her right arm, which leads us directly to the subject's face. The third is that of her left arm, which serves as a base. My personal preference would have been to have her left hand visible as I do not cut off hands and limbs when I can avoid it. Yet, this is a very effective pose, as the diagonal lines take us around the image and back to her face no matter where we begin our analysis.

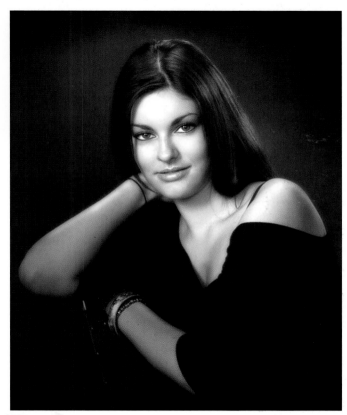

PLATE 108

The main light was a softbox positioned about 30 degrees to camera left. A fill light was used from behind the camera to bring the ratio to 3:1. A hair light almost directly over her head illuminated the subject's hair and created a very pretty rim light to her shoulder.

In plate 109, Dave used the woman's hair to create the same type of effect that we get with split lighting. The main difference is that her hair has a slight diagonal path

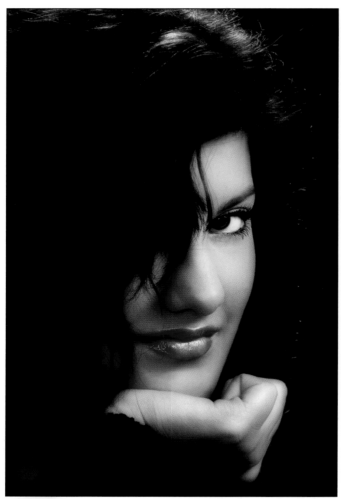

PLATE 109

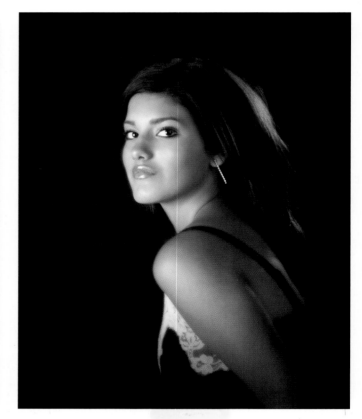

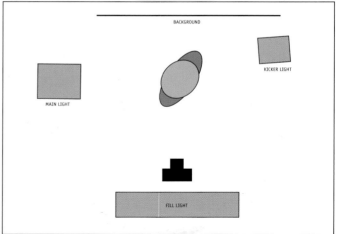

PLATE 110 (TOP); DIAGRAM 16 (ABOVE)

from her forehead, down toward her mouth. Dave had the subject almost full face to the camera, and her hair covers almost all the right side of her face. This takes us immediately to the one visible eye. The subject's hand, with her arm on a posing table, was used as a base.

The 3:1 ratio was created by a softbox placed 50 degrees to camera right. Note too, the gentle butterfly-shaped shadow to the right of her nose. No fill light was required for this image, as the purpose of the lighting was to ensure we focused our attention on her eye. A hair light was used above her head to create highlights.

In plate 110 we have a portrait that is virtually diagonal to view except that it breaks when she turns her head three quarters toward the camera. The diagonal line of her arm, the line of her back, and her hair all take us to her face. By starting with the subject in a profile position and having her turn her face toward the camera, Dave created an image that demands we look her in the eye.

The main light, a softbox, was placed directly in front of the subject to camera right. A fill light from behind the camera at $\frac{1}{4}$ of the main light exposure produced the 3:1 ratio we see in the face but a little longer ratio at her back. A light slightly behind her and to the right of the camera provided edge light on the back of her hair and added a little highlight on her back. As you can see, the pose is enhanced by the effective lighting.

It is the little things that we see in these images that make them more interesting. See diagram 16.

Plate 111 is an exquisite profile that has two diagonal lines. Her hand forms a diagonal line that leads directly to her face, and the angle of her head creates a strong diagonal line of its own. These diagonals demand that we take note of the beautiful view of the subject's eye, which is perfectly rendered because of its point of focus, not directly in front of her but at a point a little to her left.

Note that the woman's fingers are posed so that they do not all merge into one mass of skin tones.

The main light, a softbox, was positioned so that the edge nearest the camera was slightly behind the subject and slightly elevated. This created the perfect modeling. Note the way the shadows shape each of her features. The light kisses all the key elements of her face, creating a dynamic 5:1 ratio that required no fill light. Had there been a fill light, the dynamic of this portrait would have been compromised. See diagram 17.

Plate 112 is a full-length portrait with the woman in a pensive pose. Though she stood in a relatively vertical pose, her hips were at a 45-degree angle to the camera. This produced adequate feminine curves without using the S curve we discussed earlier. An important element in this pose is the position of her right arm, which is bent at the elbow. Note that her hand is turned outward so that the back of the hand rather than her palm is placed at her hip. Note too that she placed her weight on her back foot. This lowered her left shoulder, eliminating too square a view of the shoulder line and allowing her to relax her right leg.

The arm at the pillar is at the right height and prevents the hand compromising the view of her head. If it had been higher or lower it would have changed the shape of the composition, as she would have had to adjust her distance from the pillar.

The main light was placed at camera left and a kicker light was directed to her face, creating the brightest area of the image other than the pillar and the primary point of focus. No fill light was required as the pillar reflected light back to her face and figure, creating a little over a 4:1 ratio.

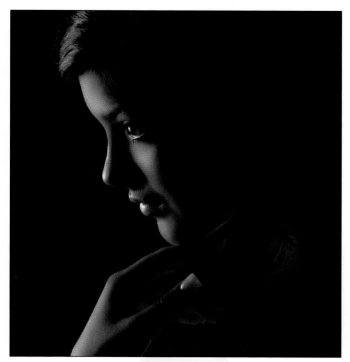

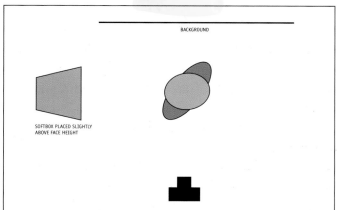

SOFTBOX PLACED SLIGHTLY
ABOVE FACE HEIGHT

BACKGROUND

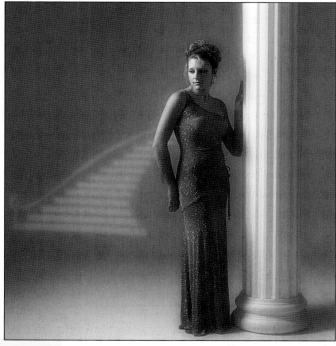

PLATE 111 (TOP); DIAGRAM 17 (ABOVE)

PLATE 112

10. Tom Lee

Tom Lee is one of Britain's leading portrait and wedding photographers. He is vice president of SWPP and has a Fellowship with the society. Tom has been awarded the SWPP Contemporary Album of the Year Award on two separate occasions. He has also presented seminars on digital photography techniques and workflow to audiences across Britain.

Plate 113 is a window light portrait of a bride with her shoulders square to the camera and her head turned to a profile view. In this composition the shoulders provide a base for the profiled face.

The position of the bouquet prevents the vertical position of her arm from being exposed to the camera. The pose also allows us to view a little of her bared shoulder, which is always a nice touch.

The illumination was from a relatively small window at camera left. She was positioned close enough to control the light so that it was primarily focused on her face and bust, creating a natural vignette.

Note that the subject was positioned far enough from the background to allow some light to illuminate her veil.

Plate 114 is a nicely exposed portrait of a woman in black, which will always require accurate exposure in order to show texture in the black material.

Tom uses the same lighting setup in all his studio portraits with minimal variations depending on the subject, though he may reverse it to suit his subject. He is very much confined by the small space he works in.

Tom positioned his subject 7 feet from the camera. His main light, a softbox, was placed 54 inches from his subject and 45 degrees off camera (30 degrees from the subject position) at a height of 78 inches. His fill light was a 32-inch snoot shot through a semi-opaque umbrella (often referred to as a shoot-through "brolly") a

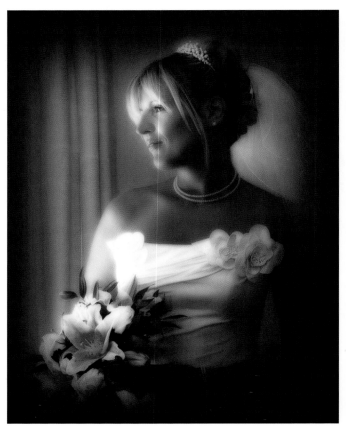

PLATE 113

little to the right and behind the camera at a height of 9 feet. The "brolly" softened the light, which otherwise would be too specular.

For separation Tom placed a light high above his background 3 feet from the subject.

Tom also uses a consistent exposure technique dictated by the limitations of his camera room. He has his Nikon D2x 70mm lens (105mm equivalent) set at f/5.6, which matches the main light output. His fill light is powered at f/2.8 or ¼ the power of the main light, which reduces the light ratio without us being able to see

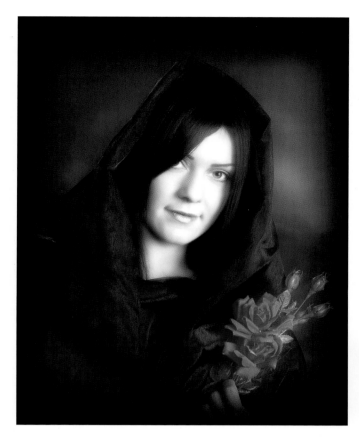

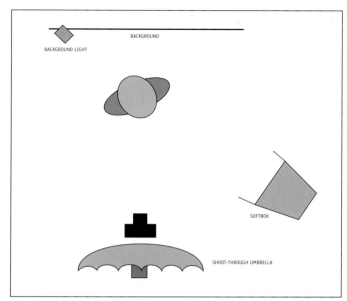

PLATE 114 (LEFT); DIAGRAM 18 (ABOVE)

it in the image. Used at this height, the fill light mostly prevents us seeing a second catchlight in the subject's eyes. See diagram 18.

Had the light been farther off the camera plane, the shadow caused by the subject's hair would have fallen on her eye. Had the light been closer to the camera, the rendering of her facial features would have been flatter and less defined.

The same effect can be achieved by feathering the light across the face from a position closer to the camera. The minimal fill light helped to bring out the texture of the black material. A little light was projected onto the background to create separation.

The pose is one that has her facing the camera. Without the nice diagonal, this would be a less interesting image.

Plate 115 shows the bride strategically placed in the composition. This required Tom to focus his light onto her without overlighting the rest of the composition. To do this, he used the ambient light as well as his flash.

The pose is elegant and has the desired S curve. The placement of the subject's hand just below her hip created a nice line that leads us up along her arm and to her

PLATE 115

face. Her hand at the mantle creates just one of the notable curved lines in the pose. Note that the subject placed her weight on her right foot so she could relax her left leg. This created the always desirable break at the knee, an element that generally creates a tapering of the legs as we follow them to the ankles.

PLATE 116 (LEFT); PLATE 117 (FACING PAGE)

her ankles and wrists crossed and her head tilted away from the camera presents a very interesting composition with an unusual perspective.

The pose was enhanced by the light from above, which created contrast and increased the dynamics of the image. It is an example of how two disciplines, posing and lighting, should be complementary and considered together.

The woman's long blond hair worked well with the pose, covering any potential exposure of sensitive skin. At the same time the heavy shadow under her chin to the top of her chest accentuates the image of her face. Though we normally look for bright tones as leading lines, it is the shadowed area below her that leads to her face.

Plate 117 shows a three-quarter back view of a woman whose face is turned toward the camera. We do not often see this style of pose, but it can be very effective when we want to accentuate the woman's bustline, as Tom has in this elegant portrait.

By using the fabric around her waist and over her arms Tom created the appearance of separate elements. This automatically draws our attention to the bustline as it is immediately above the lighter-colored fabric. The portrait is unusual and presents a different perspective of the female form.

In this portrait Tom made a minor adjustment with his fill to create the 4:1 ratio.

Though nude photography is not a focus of this book, I've elected to show plate 116 because it has very interesting elements that can be used in portraits in which the subjects are clothed.

First, let us examine the pose. Having the seated subject facing directly at the camera hugging her knees, with

When we need to show the back of an elegant gown, we can use the strategies used in plate 118 as a guide. This angle has greater impact and style than one in which we see the subject with her back square to the camera.

In this pose, every detail of the gown is clearly visible. We are also able to see who the woman is in this pose. Be-

PLATE 118

PLATE 119

cause she is at a 45-degree angle to the camera, we are able to see her features. If she were to turn her head toward the near shoulder she would not have to stretch herself in order to look at the camera.

Even though the image has been heavily vignetted it appears that window light from in front of her served as the main light for the image. Fill light at about ½ of an f-stop less than the window light was employed to light the back of the gown and her shoulders.

Plate 119 shows the subject positioned about 10 degrees off the plane of the camera. The position of her arms and hands is natural, and her left forearm is angled so that it does not run directly across the camera. The break of her wrist caused her hand to be nicely elevated.

The main light, a softbox, was placed 45 degrees to camera right and illuminated her face with virtually no shadow detail at the left of the subject. A hair light was placed behind her. This lighting pattern was designed for this subject to reduce the depth of her right jawline.

Plate 120 is a very pretty profile style pose, with the subject's head turned toward the camera for a three-quar-

ter view of her face. This automatically produced a slightly submissive head position. Her right hand was placed gently on the table, and the break in her wrist produced the "live swan" pose.

The main light was positioned 45 degrees to camera right, and a hair light was placed behind her to throw light onto her hair and the back of her gown. The fill light was placed behind the camera at a height of 9 feet. The output was ¼ less than the main light, for a 3:1 ratio.

In plate 121, Tom used an over-the-shoulder pose. Tom was positioned a little farther toward her back and was therefore able to show the subject's bare shoulder and a little of her back. This also caused her to lean back a little and created a slight diagonal.

It has been said that a woman's bare shoulders are especially attractive to a majority of men, who spontaneously want to kiss them—hence the notion of showing them off in portraits.

The main light was a softbox placed a little to the right of the camera. This light also provided the illumination on the background. This time the fill light was increased

PLATE 120

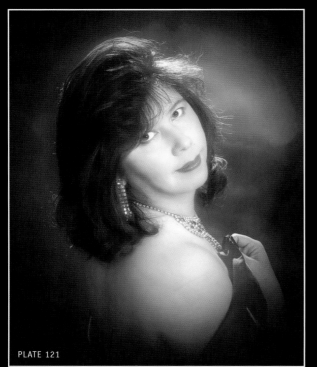

PLATE 121

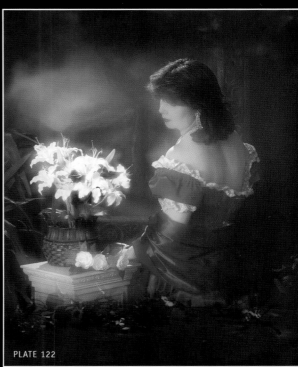

PLATE 122

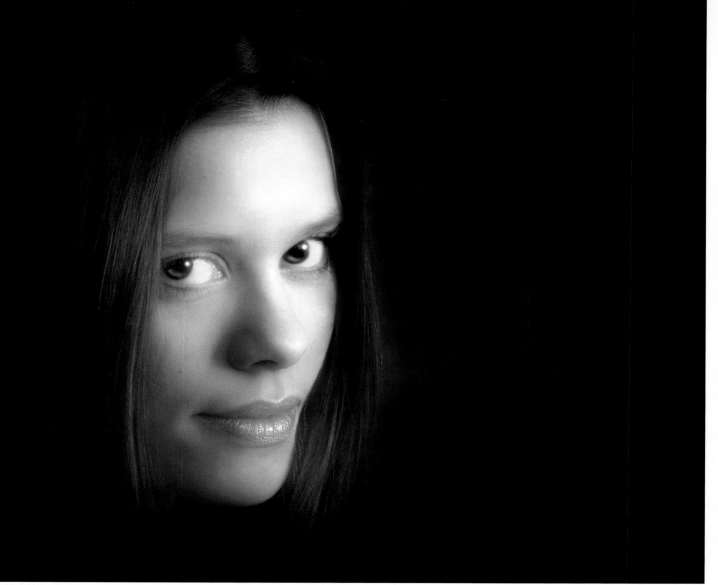

PLATE 123

to almost the same power as the main light to create more of a glamour style. A hair light was positioned high behind the subject, directed at the back of her head.

In plate 122, Tom used a pose similar to that shown in plate 118, an angled view of the subject's back. Here, Tom's slightly elevated camera position shows a little more of the top of her shoulders. This presentation is unusual because we see only part of her face covered by her hair as she looks to her left and a little downward.

The main light, because it was almost directly in front of the subject's profiled head pose, also created a totally open light effect on her face with just a hint of modeling. The hair light positioned high at the background created an edge lighting effect on the front of her near shoulder. The fill light, placed a little to camera right, reduced the ratio to 3:1.

Tom's last image in this chapter, plate 123, is a beautiful close-up that takes you deep into the subject's eyes. Tom's angle of view, with the camera level with the top of the subject's head and the lens tipped downward to her eyes, is a perspective that will always produce an expression with great appeal. The subject's eyes demand that you meet her gaze. The tilt of her head to our left is subtle but important because it is one of the reasons we have the expression we see.

This portrait is yet another demonstration in how we can create a dynamic image with just one light. This light is at 45 degrees to the right of the camera and creates a 3:1 ratio. Because of the angle of view, combined with the position of the light, the hair has enough illumination to frame her face.

11. Paul Rogers

Paul Rogers is an award-winning photographer from Illinois. He has continuously produced images that have scored the coveted 80 in both the Professional Photographers of Northern Illinois (PPANI) and Illinois State conventions, and by the time this book is on the bookstore shelves he will have received his PPA Masters Degree. Specializing in wedding and senior high school portraiture, Paul has followed a concept of making the emotions of his subjects shine through in his portraits. He tells us about how his six-year-old daughter dreams about her wedding day and realizes how important his images are to his brides and also his high school senior girls.

Paul says he likes to keep his lighting simple. In the studio, he uses one main light and a reflector, which sometimes serves as a kicker light, behind the subject and opposite the main light. His studio is in a basement and prohibits the use of a hair light. When conducting studio sessions, he typically uses a 4x6-foot softbox, which provides wraparound lighting.

The closely cropped, full-face portrait in plate 124 shows a young woman hugging her leg. The relaxed pose allowed her to communicate with the camera without changing her position. The lens perspective was almost directly horizontal, with virtually no tilt up or down; this provided the viewer with a direct connection to the eyes of the subject.

The large softbox Paul used adequately illuminated the subject's hair and produced a smooth transition from highlight to shadow for a 3:1 light ratio. We can see some separation from the background. This was achieved by positioning the subject at the right distance from the

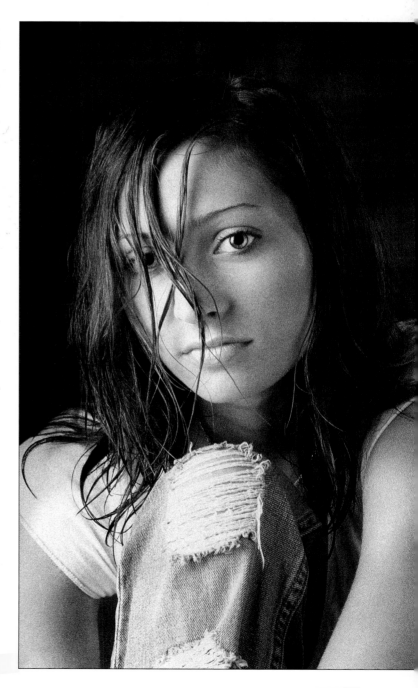

PLATE 124

background. This can be determined through metering or by trial and error.

The bridal portrait in plate 125 was illuminated with a Quantum flash high and to the right of the camera. The subject's pose is expressive. Her extended arms create lines that draw us to her face, and the shadows from her arms and the line of the railing create additional interest. The pose is akin to the fashion images we see in magazines and will appeal to the modern bride.

The portrait in plate 126 is a knock-your-socks-off senior image. Though the subject is attired in jeans and a sweater, her left arm is in a very feminine position. Note, too, that she is virtually square to camera, something you should do very selectively.

Paul's lighting strategy was perfect for this image. The position of the softbox created a very pleasant pattern on the subject's face with a perfect butterfly-shaped shadow between her nose and upper lip. A reflector was placed a little behind the subject at camera right, creating delightful edge lighting to her left side. See diagram 19.

The portrait in plate 127 has much greater contrast than most of the previous images we have seen. The sub-

ject was laying on the floor. The single light source—a snooted studio strobe—was placed to the right of the subject. Her pose and the lighting combine to great effect, and the resulting shadows and texture in the fabrics create additional interest without reducing the focus of the portrait.

Note that the subject's head was turned so that the light fully illuminated her face and produced a modified loop pattern below her nose. Though there are many

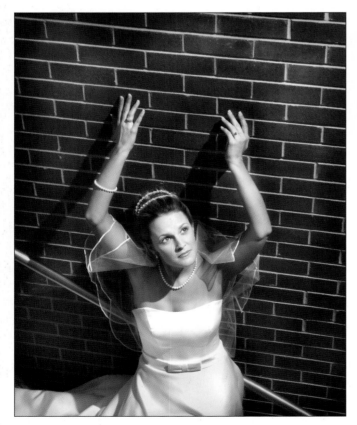

PLATE 125

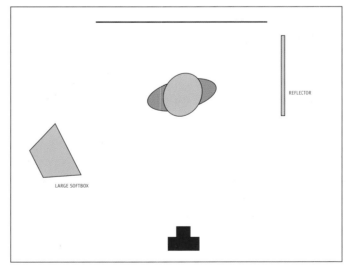

PLATE 126 (TOP); DIAGRAM 19 (ABOVE)

REFLECTOR

LARGE SOFTBOX

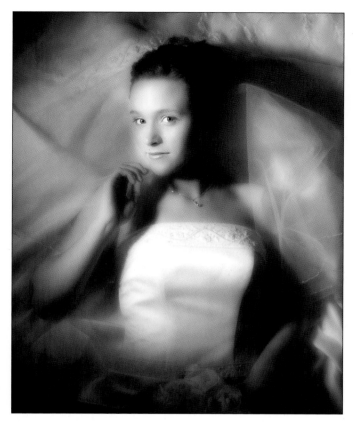

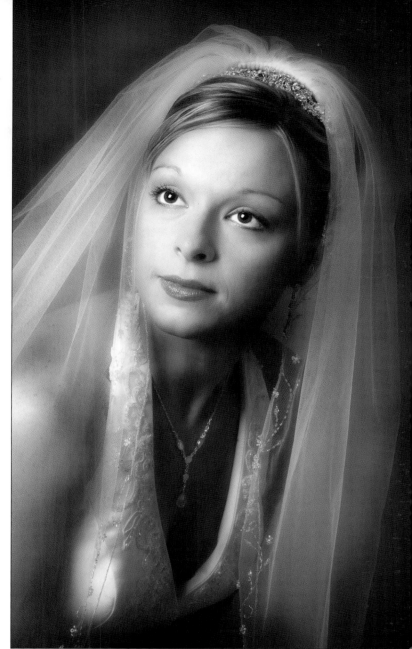

deep shadows throughout the frame, they actually work to great effect in this portrait.

Plate 128 is another portrait with a long lighting ratio. It's the look we expect in a bridal portrait, but Tom has made it work to great effect in this image. Here, the subject was looking upward and the camera was positioned higher than usual, making the light focus on her face in a way that a traditional setup would not. Because we are drawn to the brightest part of the image we do not notice the long 6:1 ratio until we have already seen the great expression.

The subject's pose creates a diagonal from the bottom left toward the upper right of the frame. The light delicately picked up her necklace and the lines of her gown, contributing to the very feminine look of the portrait. Too often photographers fail to demonstrate the femininity of their brides while considering all the other factors. Remember that a bride is a woman in a gown and not simply a gown with a woman in it.

As someone who is hypersensitive to hand poses, I find that the portrait in plate 129 works exceptionally well. Her hands are positioned so that they do not en-

croach into her face and allow us to see her chin without it being distorted. The hands are in a graceful presentation and do not appear clawlike or distracting.

Another consideration is where to crop the wrists or forearms to avoid a "photographic amputation." Paul got it just right in this image. The overall effect is very pleasing and no doubt excited the bride and her family as well as her groom.

The dreamy expression in plate 130 was achieved by having her hand (not seen in the image) supporting her weight, which slightly reduces the sensuality of her shoulder, yet this does not take away from the charm of the portrait.

Having her lean on her hand brought her to the angle of view that is diagonal from bottom left to upper right and brought her head to a point at which it was perfectly positioned to the light.

PLATE 130 (TOP LEFT); PLATE 131 (LEFT); PLATE 132 (ABOVE)

The light created a modified loop and butterfly-shaped shadow below her nose. Note also that there is light on all the important elements in the facial structure—the forehead, nose, cheeks, and chin. The overall effect is that the shadow side draws us across the image to her eyes and the diagonal line of her nose, mouth, and chin.

Plate 131 is a striking portrait of a high school senior. The pose and the angle of her figure have great lines and impact. Note that her hands and arms are positioned in an unconventional yet natural pose. If we were composing a more traditional portrait, we would change the way her hand drapes over her arm so that the hand was above the wrist, but this "dying swan" hand pose works great with this portrait. To correct this would have drawn too much attention to the hand. It is an example of breaking the rules for effect.

Paul used a large softbox and a kicker light to create a brighter lighting pattern to the subject's face, which draws our gaze directly to her expression.

Plate 132 is a mood image in which the subject's eyes are almost closed. Her arms were positioned to support her as she leaned a little toward the camera. The very slight tilt of her upper body creates a gentle diagonal across the frame.

A large softbox was positioned far enough to the subject's right to illuminate her face without spilling too much light onto the front of her pose. Her right shoulder acted as a blocker and prevented the light from being too strong at the front of the image.

The overall lighting produced a 3:1 ratio from highlight to shadow that was just right for the mood of this portrait.

We have reviewed several profile portraits in previous chapters, but plate 133 is a little different as Paul pre-

SOFTBOX

REFLECTOR

PLATE 133 (TOP); DIAGRAM 20 (ABOVE)

sented his subject with her head tipped downward. By having her lean on her left arm he also created the perfect base for the profile with her chin line matching her shoulder line.

Her angle from the light created a perfect lighting pattern with a 3:1 ratio that is very feminine, drawing us into the shadow side of the portrait where there is detail and back again to the highlight side of the image.

For this portrait, the main light was a large softbox placed behind the bride and to camera left. A reflector

positioned at the camera position bounced a little light into the near side of her face and into the veil. See diagram 20.

Plate 134 has the bride seated on the floor in a pose that often does not work very well with some of the modern, narrow gowns that many brides choose to wear. One of the dangers of this pose is that we can actually make the woman look deformed, as we are unable to arrange her limbs in an appropriately attractive manner. In this instance, however, we are able to see her legs are drawn

PLATE 134

PLATE 135

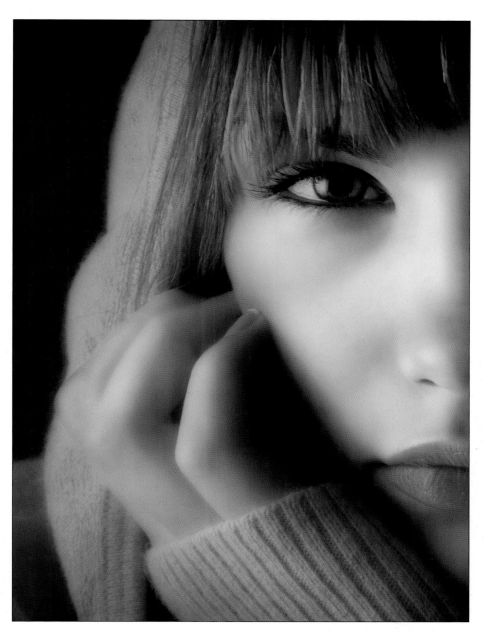

up and under the gown, which is nicely arranged. This no doubt took a little time.

What makes this portrait attractive is that Paul did not require his subject to sit upright, which would have made her look squat. Instead he had her lean on her left hand, creating a nice comfortable pose with her right hand and the bouquet resting on her right leg. This also caused her to lean into the light from an open doorway at the right of the camera. A reflector was placed just out of camera view at the left of the set to add a little illumination to the left side of the composition.

Plate 135 is another portrait showing just half of the subject's face. With her hand at her right cheek, the sub-

ject presents us with two separate but connected elements because we cannot avoid either her eye or her hand. Normally this runs the risk of creating confusion, but it seems to work very well in this portrait. Posing fingers is always problematic, but they are one of the keys to the success of this image.

To light the image, Paul placed a large softbox to the right of the camera and directly in line with the subject's position as she relates to the camera. In a split face image there is normally no need for a fill light in front of the subject as we are not able to see the shadow side of the face.

PLATE 136

12. Sheila Rutledge

Sheila Rutledge is a PPA Certified Professional Photographer. She also has a Fellowship with PPANI and is vice president of the association. Sheila's images consistently score well in print competition, and she's earned more than her share of merits. As I write this book she is close to achieving her PPA Masters degree.

Plate 136 is a head and shoulders portrait that was made with beautiful lighting. The head pose, slightly tilted to camera right, brings out the subject's wonderful smile. We are also able to see that there was great communication between the subject and the photographer, something that many neglect as they focus their attention on their technique.

To light the image, Sheila placed a large softbox 40 degrees to camera right. A fill light from behind the camera created a 3:1 lighting ratio and a gentle butterfly-shaped shadow below her nose. A hair light almost above her head illuminated her hair. The result is beautiful overall lighting, and the portrait glows. This is the style of portrait that is appreciated by all age groups. Even those seeking the unusual will enjoy this image because it beautifully portrays the subject.

Plate 137 shows a subject in a three-quarter pose. Her head was turned back toward the camera and she looked slightly

PLATE 137

PLATE 138

upward to the camera height, which was just above her head level with the lens tipped toward her eyes.

Folded arms are popular in casual images, and in this portrait the pose works especially well because the subject slightly tipped her shoulders to her left, presenting a slight diagonal from the bottom left of the frame to her head, which is a little to the right of the composition.

Sheila used a main light at 45 degrees to the right of the camera, a fill light from behind the camera, and a kicker light to the left of the subject. A hair light helped to draw attention to her face. The effect is an almost three-dimensional lighting pattern.

It was not originally my intention to include mother and child images in this book, but I found the portrait in plate 138 truly charming. Also, it shows us how to effectively pose two females in a close-up. The child is over her mother's shoulder, but the image is mostly about the great smile on Mom's face. The same concept could have

been achieved with older subjects, and when the opportunity occurs we should use it.

Note the angle of the mother's shoulders. They are fairly square to the camera, but she still has her head turned for a flattering view. Sheila placed a softbox at camera right and a fill light behind the camera. A hair light was positioned a little to the left and over the subjects' heads; this produced a sparkle in the child's hair. The main light created highlights in the mother's hair.

The soft overall illumination shown in plate 139 is consistent with Sheila's portrait style. In this image, it created a very nice lighting pattern that modeled the subject's face to perfection. This lighting is flattering and produces radiant skin tones, especially when the exposure is accurate.

A tree just outside of the right edge of the frame served as a supportive prop and allowed the subject to lean slightly to her right with her right hand at her neck below her ear. The portrait, with its peek-a-boo impression, is youthful and full of vitality and clearly required communication with the photographer.

Plate 140 is a very nicely posed high school senior portrait created outdoors. Having a subject's arm pointed almost directly toward the camera can create a slight foreshortening effect, but Sheila compensated for this by using a relatively high camera perspective. As a result, the circular line created by the subject's arms and hands draws us to her face and glowing smile. Because the subject was seated and leaned on her right elbow, there is a very nice triangular line that runs from her legs down and then up through to her shoulders. Her head, tipped away from her shoulders, gives us a shortened S curve.

Sheila carefully positioned her subject in an area of the scene where the light was even and flattering. This produced a light ratio a little less than 3:1, but the subject's pretty features were nicely rendered.

To create the pose shown in plate 141, Sheila had her subject rest her elbows on a table and bring her hands up to her chin. This created a triangular shape in her arms that leads to her expression. Because her head was tipped slightly toward her lower shoulder and her hands are not centered directly under her chin, the portrait is more interesting than a traditional, more vertical presentation.

PLATE 139 (TOP); PLATE 140 (RIGHT)

PLATE 141 PLATE 142 (FACING PAGE); PLATE 143 (BOTTOM LEFT)

The lighting is another example of Sheila's overall soft lighting pattern. In this portrait, the hair light created increased highlights in the hair. The portrait meets the social and professional needs of the client.

Sheila created the portrait shown in plate 142 from a high angle in an outdoor environment using only slightly diffused sunlight from above as indicated by the shadows below her chin. Light from this direction models the cheeks a little differently than a light from a more conventional direction, and in this image we can see how beautifully it has done so. Note the very attractive modeling of the bride's face and shoulders.

Sheila had her subject posed at the trellis with her left hand resting on an upright beam. Because of the high camera angle, the placement and angle of her right arm resulted in only a slightly foreshortened view.

Plate 143 is a business portrait with charm and vitality. This is the type of image that most photographers are required to create, but we will rarely see one better than this. Sheila slightly modified her technique to create a little more modeling of the subject's face. Her main light was once again positioned at the right of the camera, but this time she reduced her fill light power to obtain a 3:1 ratio to bring out more of the subject's character. A hair light was placed slightly behind the center of the subject's head so as not to interfere with the facial modeling. The result is a very businesslike, client-pleasing portrait.

13. Edda Taylor

Edda has combined the art background she acquired in Europe with her photography to earn a reputation as one of the most recognized names in the photographic industry. Her unique style and approach to photography have earned national and international acclaim, including two prestigious international awards—

PLATE 144

the Gerhard Bakker Memorial Award and the Kurt Lieber Gold Award. Edda says, "We as photographers are artists and poets and share the common trait of being able to take the simple and make it special. The result is nothing short of magical."

Edda has lectured throughout the United States and Europe and has taught in Amsterdam, Paris, Nassau, and the World Congress in Cologne, Germany. She has also taught several courses at the Winona International School of Photography. She holds Master Photographer and Photographic Craftsman degrees from PPA. She is fluent in French, Italian, Greek, Turkish, and English.

Edda says that there is something beautiful in every woman and she tries to find it and bring it out in all her sessions. She "catches" on camera what she calls Body and Soul. The goal is to portray that which the camera can grasp (body) in order to capture an essence of quality unique to the subject (soul).

Edda creates many of her images using only window light, which also bounces off the floor. Plate 144 shows the result of employing this technique. We are able to see the large window at the right of the portrait and the way the light on the floor reflects up to the subject.

We can see the effect of the light on the wall to the subject's right. Edda positioned the dancer at the edge of the light's directional path to model her face. The reflected light evenly illuminated the rest of her figure with just a touch of highlighting on her arms.

The pose comes naturally to a ballet dancer, but it can also be used as a starting point and modified for posing others. Note, too, the use of this setting, which makes this image something that might be displayed as fine art.

In plate 145, Edda used a smaller window as her light source and created the image in the frame of a mirror in

PLATE 145

the old building. This simply reversed the lighting pattern, as we now see the subject from a reverse perspective. The subject was positioned so that she was directly in the path of the semi-directional window light, which created what could be described as a gentle split lighting pattern modified by the reflected light from the walls and her blouse.

The pose is a simple one. Edda positioned the subject with her back against the wall and had her casually lean her upper body a little forward.

Using the old vanity mirror allowed Edda to create a portrait of greater interest than would merely closely cropping the portrait into a simple 8x10. Taking advantage of on-site props can make a good image a great one.

In plate 146, Edda broke several of my golden rules in posing hands and arms—with confidence. The pose she selected demonstrates a feeling of comfort and self-protection—and it's one that works strictly for women. Though the subject showed the back of her hand and her forearm appears a little foreshortened, their positions are relevant to the concept of the portrait.

To light the image, Edda positioned a softbox 50 degrees to camera left and placed a reflector panel to the subject's left. A hair light was positioned near the background, and a background light was placed 3 feet behind the subject and 2.3 feet from the background. (See diagram 21.) These distances are important when calculating exposures and getting the desired illumination for separation.

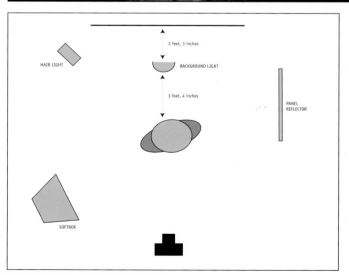

PLATE 146 (TOP); DIAGRAM 21 (ABOVE)

The illumination in plate 147 is soft, and the skin tones and facial structures are delicately sculpted. The ratio from highlight to shadow is 3:1.

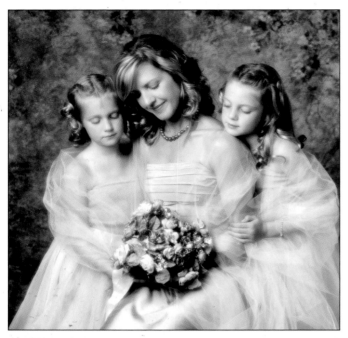

To pose this group, Edda positioned the mom in a three-quarter view. Each of the girls was then positioned in a three-quarter position with the inside shoulder tucked behind Mom. This brings the trio in nice and tight for a lovely composed group portrait.

When posing such groups the positions of the feet are key. When the feet are properly posed, the body falls into the position we desire to present. Edda began with the proper positioning of the mother's feet and then directed the positioning of the girls.

Note the angle of the subjects' arms and hands. Mother and daughter at our left have their forearms at a downward angle toward their hips. The girl's hand on her mother's arm is a nice, warm touch, and the fact that we can see the back of her hand is not an issue because the impression is childlike and perfectly natural.

To create the image shown in plate 148, Edda again used the lighting setup shown in diagram 21 (see page 91). The large softbox produced soft illumination, and a

PLATE 147 (LEFT); PLATE 148 (BELOW)

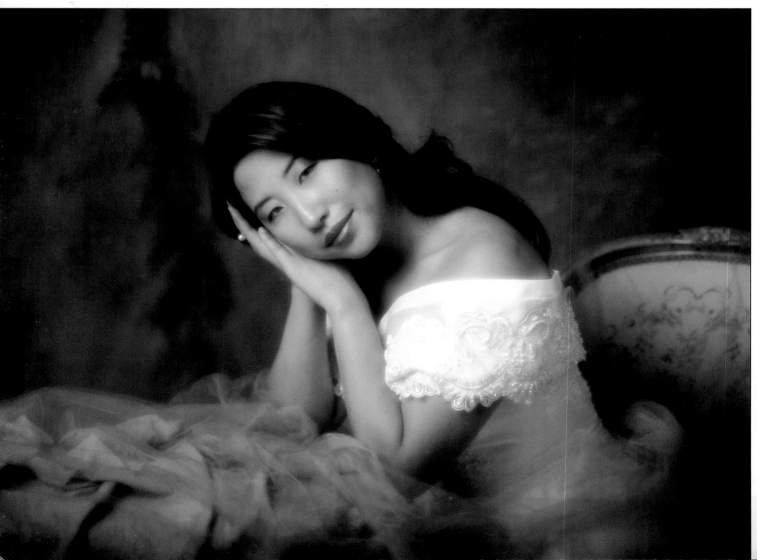

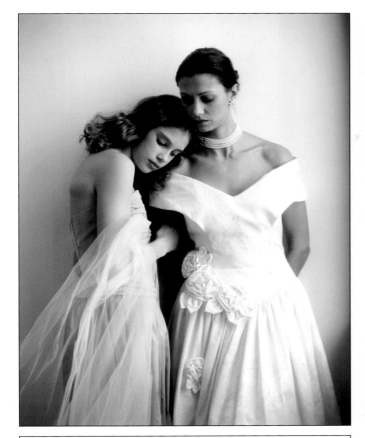

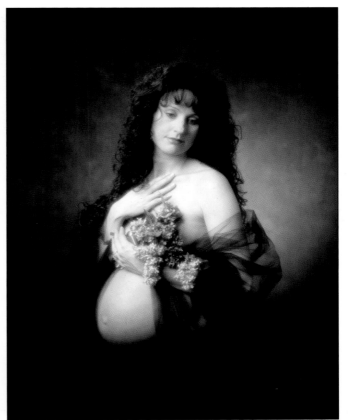

PLATE 150

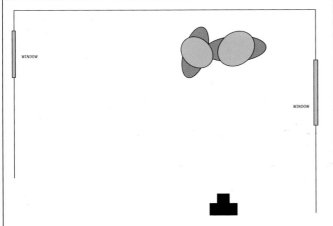

PLATE 149 (TOP); DIAGRAM 22 (ABOVE)

reflector was used to balance the main light for a gentle rendering of the face. The shadow below the subject's chin helped to frame her face. Balancing the light for a soft wraparound effect is very flattering to the delicate female skin tones and bone structure.

The pose used is restful, and the mood shown in the subject's eyes is the result of her being comfortable and relaxed. The triangular pattern of the lines of her arms and the gentle leading line that runs from her near shoul-

der to her elbow and then back to her face help to make this a well-executed image. The diagonal line of her back is key to the success of the portrait.

Plate 149 was made by light from two small windows, with reflected light from the white walls and the floor providing additional illumination. One window was to camera right, and we are able to see the shadow of the window frame at our right. The window to the left of the camera was farther from the women and produced less intense light, creating the 3:1 ratio. See diagram 22.

Posing the mother square to the camera with her hands resting on the wall behind her allowed her daughter to hold onto her mother's arm with both hands then drop her head onto her mother's shoulder. Having Mom turn her head to meet her daughter's was the final step in creating the tender mood the image portrays.

The portrait in plate 150 is a variation on the theme of creating tasteful images of pregnant women.

In a maternity portrait, a woman's hands are often placed on her rounded stomach, but by using the flowers to draw the viewer's gaze, attention is more subtly drawn to the pregnant figure. Note too her uncommon

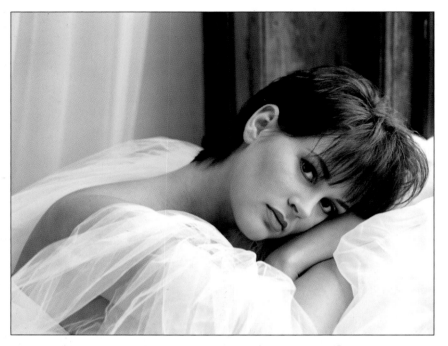

PLATE 151 (TOP); PLATE 152 (BOTTOM)

presentation: the subject is neither square nor profile to the camera, but at a three-quarter view.

The placement of the woman's hand on her chest is a common characteristic in Edda's portraits. We may do well to use this element in our portraits when appropriate, but we must beware of making it a distraction.

The lighting setup was that shown in diagram 21 (see page 91), except that the reflector panel was moved farther to the right to create a 3:1 ratio, which produced stronger modeling.

The face and especially the eyes of the subject in plate 151 are captivating. The leading line of her shoulder and neck draw the viewer's gaze to her beautiful face. Though the area where the subject's left hand and right arm meet could be visually distracting, Edda used fabric to disguise the area. The fabric simply added overall softness that further reinforced the compelling nature of the expression.

Window light was used to illuminate this lovely portrait. Note that the fabrics and other surfaces reflected light to produce beautiful skin tones and caressed her features.

The portrait in plate 152 was created by the light from a small window to the left of the camera and captured through a mirror. The image is most unusual and shows two women in different angles to the camera, each illuminated with two distinctly different lighting styles. The woman at the left, who was positioned behind the other, is shown in full profile with a 3:1 ratio. Edda placed her so that her blond hair is rendered in strong relief against the black background. Next, the woman nearest the camera was turned toward the lens. The window light pre-

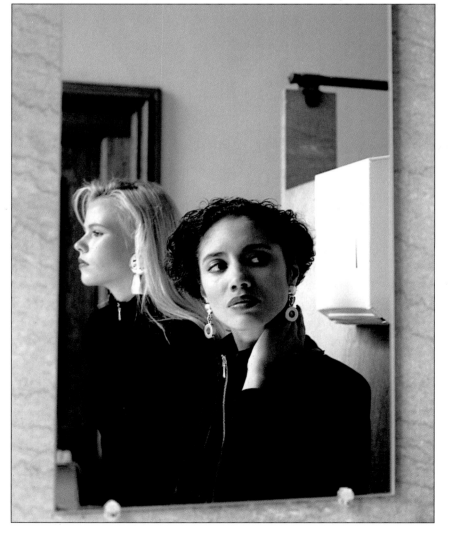

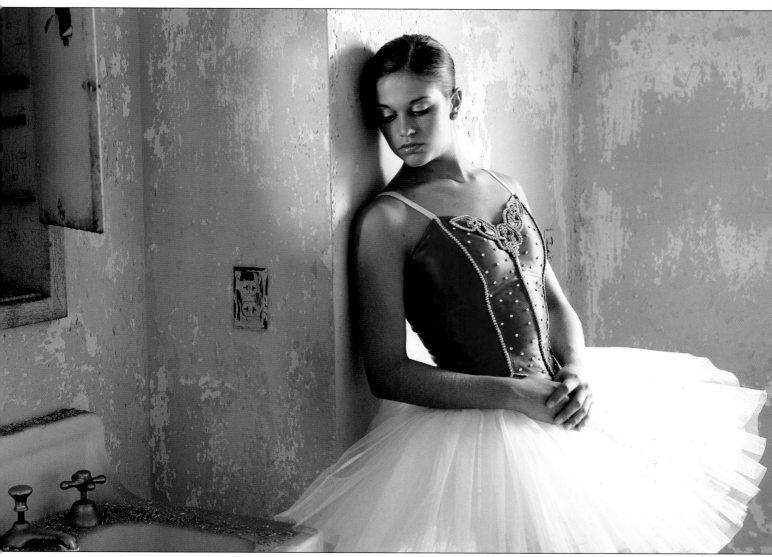

PLATE 153

sented her in a 5:1 ratio, which suits her black hair. By placing her left hand at her neck, Edda created a light-toned diagonal line that effectively draws our gaze the subject's face. This is a very intuitive presentation with great impact.

The white panel behind the women did not affect the dark-haired subject because she is a little too near us, but it reflected light onto the hair of the blond subject. In total, the lighting and posing created a fascinating double portrait.

Plate 153 is another outstanding window light portrait that has the Edda Taylor signature look. The subject was turned away from the main light source and more toward the reflected light to create a 3:1 ratio. She was positioned with her back to a wall that was at a right

angle to the window at her left. The light skimmed across her shoulders, as would the light from a softbox feathered in the same way. This created a very sensual rendering of her shoulders and bust.

The unmodified window light from the subject's left brilliantly highlighted the left side of her face so that the shadowed frontal plane of the face was rendered in a rather distinctive style—one that makes this portrait very striking. The heavy shadow that appears on the right side of her face adds a sense of drama that is well suited to the dynamics of the composition and the overall impression Edda wanted to create.

Note the slight diagonal of the subject's torso as she leans against the wall. The restful position of her arms is complementary to the overall mood of the image. Also

PLATE 154 (LEFT); PLATE 155 (ABOVE)

note the way the circular shape of her posed arms draws the viewer's gaze from her hips up and around her bodice and around her shoulders to her face.

Plate 154 is another signature portrait. The posing elements are similar to those used in plate 147. The portrait was created using the lighting setup shown in diagram 24, which produced a 3:1 ratio from highlight to shadow. This style of soft lighting is a constant in 95 percent of Edda's portraits. Note that she had the woman on our right turn her head toward the main light so that the modeling of both faces is almost identical.

Edda again employed the technique of having one of her subjects with her hand posed at the shoulder, and although it shows the back of the hand to the camera it perfectly suits this pose.

Note that the woman at the right has her right arm in a relaxed, vertical position that we normally try to avoid. However, because the entire composition is one of soft, delicate lines and tones, the pose works perfectly. There is a bit of a Renaissance painting feel in this image.

Creating the portrait of Rosey in plate 155 presented Edda with a little bit of a challenge. When we are confronted with a subject who is by conventional standards overweight, we have two options. The first is to disguise the issue. More often than not this will be, at best, halfway successful. The other option is to do what was done here, to photograph the subject as she is, in a straightforward manner. In this case, the latter option worked beautifully.

Edda wanted to create an image that showcased the subject's assets—her roundness, smile, and big personality. Rosey was presented square to the camera with her head tilted at a slight angle. Her arms and shoulders are positioned to present us with a circular line. All in all, the image tone is friendly and appealing, and we are able to see that this is a very engaging lady.

The lighting setup shown in diagram 21 (see page 91) was also used for this portrait. By adjusting the position of the reflector panel, Edda produced a ratio of 3:1 ratio that helped to reduce the width of Rosey's face.

14. Stephen A. Dantzig

Stephen A. Dantzig is a highly esteemed professional photographer and writer who specializes in fashion, beauty, and corporate photography. His articles and images have appeared in numerous national magazines such as a *Rangefinder, Studio Photography and Design, Professional Photographer.* Additionally, Stephen's engaging portraits have been featured in several regional magazines and on the covers of over twenty magazines.

Stephen is the author of three books: *Lighting Techniques for Fashion and Glamour Photography, Master Lighting Techniques for Outdoor and Location Digital Portrait Photography,* and *Softbox Lighting Techniques for Professional Photographers,* all from Amherst Media. He is the recipient of twenty-one awards of merit from the Professional Photographers of Los Angeles County, and also holds a doctorate degree in psychology from Rutgers University. Stephen currently resides in Honolulu, HI.

You will note that the fashion look in Stephen's images makes them somewhat different from those featured in other chapters of this book—something that will provide readers with more options when creating images of women.

Plate 156 features an unusual lighting setup in which the frontal plane of the subject is softly lit while there is a relatively hot lighting effect on her hair and shoulders. To create this, Stephen had his subject seated at a table with her arms at her side, then placed a California Sunbounce reflector at an inclined angle on the table to create soft, flattering illumination.

The main source of light was a large softbox fitted with a Photoflex Circlemask to create a natural-looking round catchlight in her eyes. The softbox was placed as close as possible to the subject without it showing in the images, ensuring the light would be very soft. This light

PLATE 156

was positioned high above the camera and directed downward to create a lighting pattern with a modified butterfly shadow below her nose.

A silver reflector placed below her chin softened the shadow below the chin and nose. It also created the second catchlight in her eyes.

While her body is square to the camera, her shoulders and arms are still posed to create pleasing diagonals in the frame. Her head, too, is slightly tilted.

PLATE 157 (ABOVE); DIAGRAM 23 (LEFT)

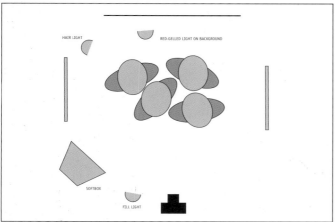

Plate 157 features a very interesting composition for a group portrait. The four women's faces are essentially posed along two diagonal lines; one links three women (from top left to bottom right) and one links two faces (from middle to top right). The angle of the four faces to the camera is a little different in each case, with the biggest difference being between the center figure and the woman at the bottom.

For this image, the main light was a softbox placed high and to the left of the camera. A hair light was em-

ployed high above the subjects, just skimming the top of the heads of the two top figures. A red-gelled light was projected onto the background.

Notice how the tight posing and matching clothes reduced distinctions between their bodies and kept the focus on the faces. The result of this is a "friendly" feel that is emphasized by their expressions.

Plate 158 has the woman seated on the floor in a casual style. The pose was designed to produce a triangular composition. This features a leading line that runs

diagonally from her bare foot up toward her face. Both of the subject's hands also fall along this direct line. Note how resting her cheek gently on her raised hand automatically tips her head toward the opposite shoulder, producing a gentle, feminine look.

The main light for this image was a 30x40-inch softbox that was placed at a 35-degree angle to the subject. Stephen also used a 40-degree grid spot as a hair light, metering it to match the power of the main light. He used a 20-degree grid spot as a fill source. A background light covered with a blue gel and metered to match the main light completed the scene.

Plate 159 is a beautiful three-quarter face portrait against a dark background that emphasizes the subject's

PLATE 158 (TOP LEFT); DIAGRAM 24 (BOTTOM LEFT); PLATE 159 (BELOW)

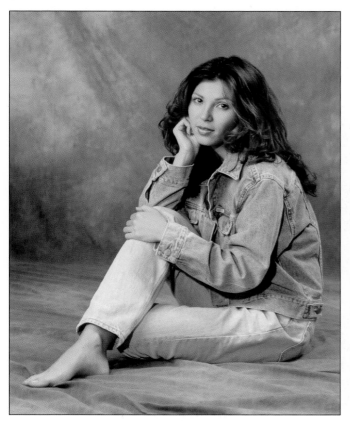

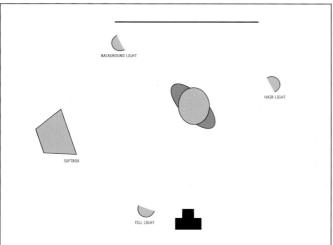

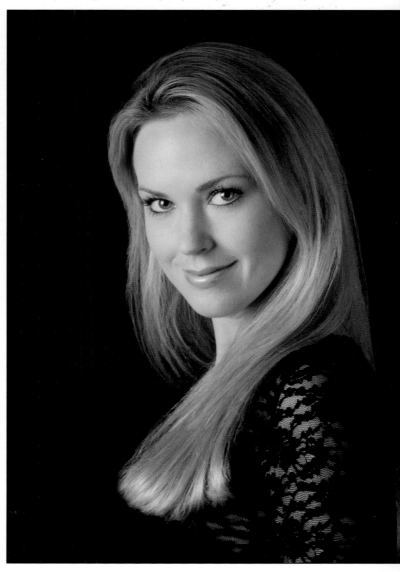

PLATE 160

PLATE 161

blond hair. The interesting aspect of this image is that her body was posed facing the wall to the right of the camera, but with her head turned back toward the camera. This is a very effective pose because it uses her beautiful hair to create a frame for her face. It also gives the image a bit of a provocative look.

The main light, a large softbox placed 40 degrees to the right of the subject, created perfect catchlights at the 11 o'clock position. A silver reflector card was employed beside the camera for fill. This soft lighting style is very kind to the female facial structure and it produced a very soft butterfly pattern below her nose.

Plate 160 exudes fun and sensuality. As in plate 159, Stephen posed the model's body in profile, then turned her face toward us. While the body pose is definitely alluring, however, the focus of this shot is actually on the model's hair and makeup. As such, her hair has been used to frame her face. Her bright expression and direct eye contact also help draw you to the intended subject.

The main light, a large softbox 45 degrees to camera left, produced a 3:1 ratio on her face and a soft butterfly pattern below her nose. Stephen used two spotlights to light her hair and a 20-degree grid spot for fill.

Plate 161 shows a more pensive mood. The subject is shown full face with her head dipped to her left and tilted a little downward with her eyes dropped demurely. The V-neck top makes a nice base for this facial rendition.

The main light was a 30x40-inch softbox placed close over the subject. A California Sunbounce reflector added below her face provided fill. This created an almost shadowless light that gently shaped her nose. Two spotlights were placed behind her to create the light that shapes her face, hair, and neck with a rim lighting effect. This adds to the mysterious look. The image was completed with a soft-focus effect added in Photoshop.

In plate 162, the lighting suggests that it was from the sun behind the camera, but the image was actually lit with a strobe in a halo-style softbox that was positioned 45 de-

PLATE 162 (TOP); PLATE 163 (BOTTOM)

grees to the left of the camera. The exposure was calculated to match the light behind her. Stephen then increased the shutter speed to cause the background to fall into rich sunset tones. This is the opposite of what we have referred to as dragging the shutter. The light produced a 3.5:1 ratio, creating depth and defining the shape of her face in an attractive lighting pattern.

The pose is very feminine, elongating her body and accenting her legs. From the top of her head, we have a gentle curve that runs through her figure and down to her toes.

Plate 163 is a fashion-style image against a low-key background with a pose that communicates a sense of motion. Her feet are posed as if she is about to spin toward us. Her left arm follows the contours of her figure; her right arm also follows the shape of her body, but additionally produces a nice curved line toward her shoulder. Overall, this pose creates an S curve that follows the line from her right foot to her shoulder. A secondary, and more gentle, S curve runs from her left foot up through her head. The white suit works beautifully to shape the contours of her figure against the dark background.

Plate 164 (next page) shows a beautifully sensuous female form with highlights and shadows that spotlight her lovely figure.

The pose is also very effective because her right arm is running down the line of her figure instead of being posed in front of her, as we would normally see. Both arms create leading lines; her left arm leads around to her face, while her right arm takes us back and forth across the length of her body.

To light this image, a large softbox was positioned to the left of the camera and above the subject at about a 40-degree angle. A second light, a strip light, was positioned at a 50-degree angle to the right of the camera. A smaller strip light was then added behind the subject to pick up a little detail in her hair. Finally, a spotlight was placed above the camera to emphasize the facial modeling. The combination of these lights is what creates the sensuous highlights and shadows. The facial modeling

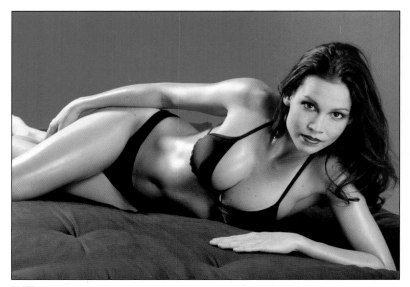

PLATE 164

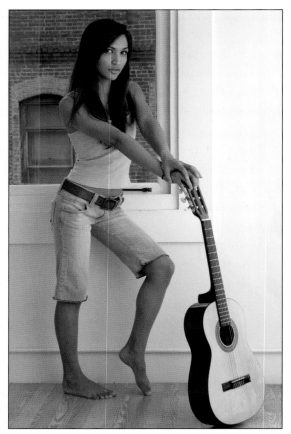

PLATE 166

is also unusual as it is lit almost identically from both sides. This is what created the highlight and shadow on her right side and lit the left side more conventionally.

The pretty young woman in plate 165 is in an unconventional pose. Her hand pose is also unusual, with her right hand clasping her left. The result, however, is very feminine and has a lot of charm. The look is completed by her expression, which is soulful and appealing.

At the time of this portrait session, the light was flat and the scene behind the subject was several stops too bright. To create this image, a grid spot was positioned just to the left of the camera, creating a more specular light quality. The shutter speed was increased to slightly underexpose the background, resulting in the rich blue tones in the image.

Plate 166 has the subject posed with her guitar in a dramatic pose that has lots of interesting lines. First, there are the curves that run

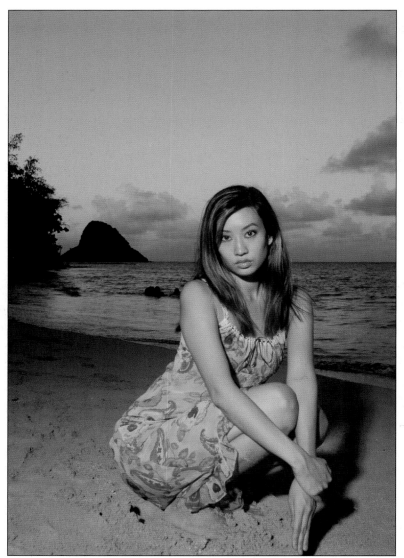

PLATE 165

from her right foot up and to her head. Second, there is the line that runs from her left toe up to her torso. Third, there is the shape her arms have created—a triangular pattern that leads your eye up to her shoulders. A nice element here is that her shoulders have a slightly diagonal line from right to left. This is a very creative and attractive pose.

Best of all, this portrait has been lit with a single light bounced off a large scrim to the right of camera and at a 90-degree angle to the wall. A large gold reflector was used as a fill light.

Plate 167 was captured with what is referred to as syncro-sunlight, a technique in which the combined light of a strobe and the ambient light are matched. First the background was metered, then the flash was adjusted to the same level. To ensure that the sea recorded as blue, an adjustment was then made to the shutter speed and compensated for by the power of the flash.

The success of the pose has everything to do with her left knee being raised to break what otherwise would have been a static line. Note, too, how her left arm reflects the line of her leg, creating an S curve.

As someone who has a strong leaning toward low-key portraits, plate 168 image is very appealing to me. Lighter skin tones against a dark background will always be eye-catching because they are in stark relief. The pose here is provocative, suggesting we should come closer. Leaning forward to rest her left hand on the chair back, the subject's body is at an angle through the frame, and the kick of her hip emphasizes the curve of her waist.

For this image, the main light was a softbox placed to camera right. A large fill light was used to soften the shadows, while still retaining the drama and sensuality of the low-key lighting.

In plate 169 (next page), the impact comes from the choice and position of co-main lights: a 3-degree grid

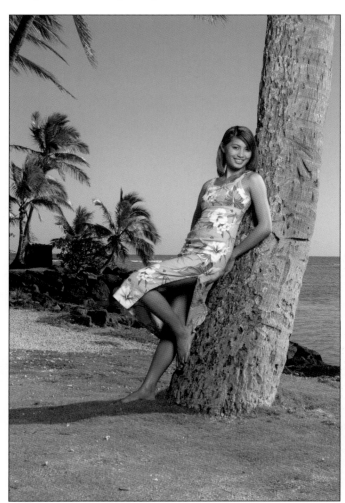

PLATE 167

PLATE 168

PLATE 169 (ABOVE); PLATE 170 (RIGHT)

spot used on the same axis as a 30x40-inch softbox. A spotlight was used as the hair light, and a rim light was added to create highlights along her arms and legs. The accent light on her chin and the edge of her face also adds a dimension that otherwise would be absent. Additionally, the shape that her arm creates as it runs over her head is soft and helps focus your attention on her face, despite the attractions of the other elements.

The motion in plate 170 is like that of a dancer; there are numerous curved lines. The line of her right hip enhances the curve from her right hand up to her face. Then, the curved line from her left hand sweeps through her shoulder to the top of her head. Making her hips the base of the pose adds another level of femininity.

Two strip banks were placed to either side of the subject to highlight both sides of her figure and create the facial modeling. Fill light was added from a parabolic placed high and to the left of the camera.

As the great variety diplayed in Stephen's work shows, your imagination is the only limit when creating fashion images.

Because my own biography appears at the beginning of this book, I have dispensed with the credits that open previous chapters. I am a romantic when it comes to photographing women. I always seek to present my subjects in a flattering manner that reflects their personality. I try to portray women as strong and confident, but also soft and sensual; I believe them to be both.

In plate 171, I created a fashion-type portrait that would appeal to a high school senior. I had the subject stand with her weight on her left foot and with her right leg extended. This moved her hips, creating a gentle curve toward her shoulders. Placing her hands on her hips created a circular line through her arms that supports her head pose. There is a little rhythm in her body language, but the key is the contradictory lighting.

Using an F. J. Westcott Strip Bank level with her position on the set I created a split lighting effect, softened by bouncing a 45-inch round F. J. Westcott Halo Mono off the white wall 8 feet to camera right, a technique I often use for fill light. I feather this in and out until it I like the effect. A spot with a colored gel was aimed at the background to create an off-center bright area. The hot left side is deliberate and it spills a little onto the left side of her face to create interest and clearly capture her expression. See diagram 26.

PLATE 171 (RIGHT); DIAGRAM 26 (BELOW)

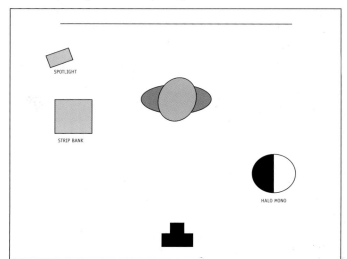

PLATE 172 (TOP LEFT); PLATE 173 (TOP RIGHT); PLATE 174 (RIGHT)

I seek to create several different impressions of each subject. In plate 172 we have the same young woman as in plate 171, but this time in a party dress. I positioned a chair perpendicular to the camera and had her sit with her arm on its back. This elevated her arm, creating a sloping line across her shoulders and allowing her hand to fall naturally. Her left hand was placed on her upper leg to create a line from her left hand to her right. The pose was completed with her ankles crossed. Because the subject's head was held high, the image is full of attitude.

To light the image, I placed a 28x42-inch F. J. Westcott Recessed Apollo at 45 degrees off camera left and bounced the light from a 45-inch Halo Mono off the wall at camera right. A high-key sweep was used as a backdrop, but because no background light was used, the background falls close to middle key.

Plate 173 is an example of using a masculine pose while retaining a feminine look. Missy's clothing and hairstyle define her femininity. Also, the young woman's hands were delicately posed. Note that her knee was positioned at a height that allowed her to lean on it.

To light this image, I placed the main light, a 28x42-inch Recessed Apollo, at 45 degrees to camera left. An 8-inch blocking strip was used to reduce the width to 16 inches. An F. J. Westcott Strip Bank was used as a hair

light. A Halo Mono, bounced off the right white wall, was again used as a fill light.

In plate 174, the same subject is shown in a profile pose, holding a rose to accent her femininity. Her shoulders were square to the camera so that her arms could be posed to create diagonals. The rose was held at a believable distance from her face, and her eye contact with the flower created an implied diagonal. This also provided the essential base for her head pose. Note that I avoided the "dying swan" hand pose for her left hand.

The main light, a 12x36-inch Strip Bank, was 15 inches behind the subject and to camera left. A second Strip Bank was placed behind the subject to light her hair and shoulder; it was set to the same exposure as the main light. Light from the Halo Mono was bounced off the right-hand wall. This was carefully modified to retain the long ratio of 4:1 to 5:1 and create a soft transition from highlight to shadow on her left arm.

For more mature subjects, a different approach is used. In plate 175, Suzanne wore a blouse and jeans, so I posed her as if we were conversing. Her right elbow was on the couch arm, and her hand passively posed. (Had she worn formal attire, I would have used the "live swan" pose.) Her left forearm was placed on her left leg, which was crossed over her right in a typically female pose. Note that the *side* of her hand was toward to the camera. Because her right arm was lifted, she leaned to the right. Turning her head slightly added a sense of vitality.

Window light from camera left provided the main light. A silver reflector was added opposite the window to create a lighting ratio slightly higher than 3:1. The ambient light in the room provided adequate separation.

Unless she is going to a party, Suzanne likes to dress casually. My second image of Suzanne (plate 176) is more relaxed than the one shown in plate 175. The portrait was created with window light. To achieve this lighting

PLATE 175

PLATE 176

PLATE 177

PLATE 178

pattern I positioned her out of the direct line of the light to have the light wrap around her. This also produced the essential highlights across her figure.

The subject was positioned just far enough from the wall so she could lean on it without being uncomfortable. Her distance from the wall caused her to elevate her left shoulder. Her weight was placed on her right foot and her left was crossed over it. Note the resulting curves from her head to her feet. This is a flattering, sensual pose for a mature woman.

It is always a pleasure to work with women who can freely express themselves. Dawn, who is shown in plate 177, was such a subject. The first task in creating this portrait was to identify a location in her home with light that would flatter her. I found this in the hallway at the bottom of a stairwell and was able to use the stairs and banister as the perfect prop.

To ensure success, we must pose the whole figure, not just the parts that appear in the portrait. Here, I had the subject place her weight on her right foot, at floor level, and place her left foot on the first stair. I then had her place her left elbow on the rail with her hand brought across in a "dying swan" pose. This allowed her long fingers to curve down and away from her face. Her right hand was positioned on the rail a little below her elbow, with her fingers slightly curved upward. This softened the line of the arm and also prevented the upper arm from appearing vertical. Finally, I had her turn her head to a three-quarter view with her chin below the level of her shoulder.

In plate 178, we see a second portrait of Dawn. The concept was based on her attire and the fact that she likes to relax on the couch. The couch was at a 90 degree angle to a large window at camera right. There was also a smaller window behind the camera and a little to the right. The light from these two windows and the reflected light from the walls created a natural lighting setup that provided a 3:1 ratio.

I posed her on her stomach with her left arm resting on the couch and her fingers loosely closed against her cheek for a very feminine look. Note that her forearm was presented at a slight angle. Her right arm is the base of the pose, and her right hand is elevated to soften the line. Separating her fingers eliminated the problem of creating a mass of skin tones.

PLATE 179 (ABOVE); PLATE 180 (TOP RIGHT); PLATE 181 (RIGHT)

Plate 179 shows a portrait of a client who considers herself a "horse person." The image was created 20 feet inside the stable so that the natural light would not produce specular highlights. A reflector to the left of the camera added a little less than ¼ stop of light, shortening the ratio and softening the split lighting pattern.

I had her position her feet apart, with one slightly closer to the horse. She held the horse's bridle with both hands and leaned slightly away. This produced the gentle curve that runs up from her left foot. The dark background allowed me to create this curve in relief.

Plate 180 was created in a natural light studio with four windows. The main light was from the window to the right. The fill came from behind the camera, and two windows behind the subject lit the background. The light from the window immediately behind her was reduced because it was close to an outside wall. A large reflector was positioned in front of her for additional fill.

I posed Megan with her back against the edge of the window. Her left hand was placed behind her, angling her arm. Bringing her right foot over her left with her toe on the floor, produced another curve. She rested her head against the window to complete the pose.

Plate 181 has Megan in the same setting but in a relaxed position on the floor. This time, the plant was moved to block the light from the two rear windows so

PLATE 182 (TOP); PLATE 183 (BOTTOM)

that they provided only background light. The reflector was brought closer to the subject to ensure the lighting was consistent along the length of her figure.

The pose was intended to convey a "time out" and was designed to show her great legs. This was achieved by pulling the right leg up so the back of her knee was just above that of her left. (This is the opposite of what Monte Zucker arranged in plate 165.) Her left leg was extended as far as possible while keeping her foot flat on the floor. Having her hands posed on her right knee and her head turned and against the wall, eyes closed, created the impression of a moment of relaxation. The shoes were placed as the final element in the composition.

My subject in plate 182 competes in national figure competitions. Our goal was to create images that would be displayed on her website, from which she would sell posters, calendars, and exercise DVDs. These had to appeal to both male and female followers of the sport.

I posed the subject just inside a doorway with her right hand at an upward angle that pushed her upper arm back to form a diagonal. I had her head tipped toward the doorframe and also had her bring her hips to the frame. This ensured a nice curve along her back starting from her jeans and flowing up around her shoulders.

The light was from two windows, one to camera right and the other behind her, and an on-camera Metz Mz54 with a Gary Fong Light Sphere modifier. This was bounced off the ceiling for a little frontal light.

The face was turned into the light; the mask is illuminated and there is a hint of a butterfly-shaped shadow below her nose at her right. The warm daylight from the right enhanced her rich suntan.

Plate 183 shows the same subject at a lake. The time of day was important, as we needed to ensure the filtered sun would illuminate her from the left of the camera, wrapping around her to model her face and figure.

The subject was positioned in a profile. Using her arm strength to support her weight, a diagonal was created from the rock to her head. Her right leg was drawn upward and her foot was placed on the side of the rock. Her left foot was extended into the water. Note that in posing her body as described, a strong diagonal was formed that runs from the bottom left to the upper right.

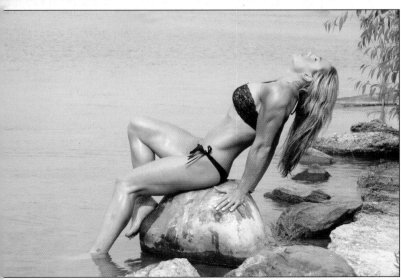

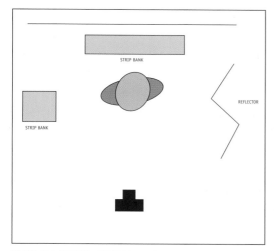

PLATE 184 (RIGHT); DIAGRAM 27 (ABOVE)

Plate 184 was created in the studio with the purpose of demonstrating that a well-trained, muscular woman athlete can look elegant and beautiful when formally attired.

I posed the subject with her back foot bearing her weight and her toes turned sideways to the camera. Her front foot was placed at her instep and aimed at the camera. Her right leg was relaxed to produce a break at the knee. She was very slightly angled to camera right to accentuate her bust-line. Her arms were posed with slight diagonal lines in a soft, feminine style to create an overall tapered line from head to toe. We also achieved the desired S curve as well as many attractive secondary curves that will delight male viewers.

A Strip Bank was placed to the subject's right and level with her position on the set. A second Strip Bank was placed slightly behind and above her head to illuminate her hair and shoulders. The lighting setup was completed with the addition of an 8x4-foot concertina reflector to the camera right. The result is elegant with lots of charm *and* evidence of her muscularity. (*Note:* The concertina reflector was made from a 8x4-foot sheet of Gatorfoam cut into 16-inch panels. The panels were hinged with gaffer tape and painted black on one side and white on the other. See diagram 27.)

In plate 170, Monte Zucker used specular highlights to create a three-dimensional impression of a dark-skinned subject. In plate 185, I took a different approach to recording the beautiful dark skin tones of my subject.

A strobe-powered F. J. Westcott SpiderLite (also available with a choice of incandescent or fluorescent light) produced a soft light that approximated daylight and illuminated the subject's skin tones, rendering her skin smooth and cleanly lit without producing specular highlights. It also allowed me to capture texture in the black fabric—this is something that using a more specular light would not have allowed.

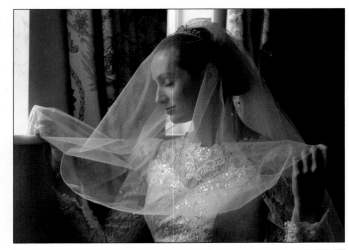

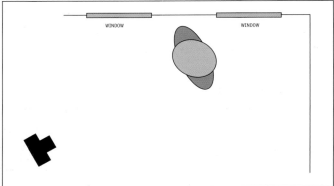

PLATE 186 (ABOVE); DIAGRAM 29 (TOP)

I had the subject tilt her head a little to our right to present a three-quarter face to the camera. Her hands, one above the other and presented at differing angles, pulled her black shawl closed. My rule that we should not show a woman's knuckles was deliberately broken here because she is shown clasping the wrap, and the position is therefore quite natural. I simply refined the hand position to ensure it was as feminine as possible.

In plate 186, my goal was to produce an image that reflected the soft, beautiful impression I had when I saw this lovely woman.

Shooting through a veil softened the image. To add a little fashion style and more emotion, I had the subject hold the veil with her hands extended. I then encouraged her to dip her chin and close her eyes and dream of something she loved.

The lighting was all window light from just in front of the subject and to her right. She was positioned at 25 degrees off the plane of the window. As a result, the light wrapped around her face and illuminated her gown with barely a $\frac{1}{2}$ stop of falloff from our left to our right. The

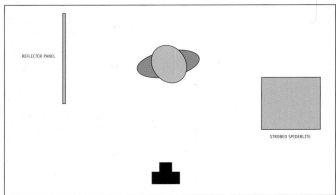

PLATE 185 (TOP); DIAGRAM 28 (ABOVE)

The SpiderLite was positioned 90 degrees from the camera with its farthest edge level with the subject's head in the set. Its light was feathered straight across the plane of the camera to skim across her face. To complete the setup, a 8x4-foot vertical reflector was placed at the subject's right side. See diagrams 34A and 34B, one a bird's-eye view.

window behind her provided separation behind her neck and a little to the back of the veil. See diagram 29.

Plate 187 features another bride. The subject was seated in the center of a couch, barefoot, with her shoes and bouquet at the sides of the composition. Her gown was pulled up onto her lap in order to show her legs with crossed ankles. I had her rest her elbows on her knees and cup her face in her hands. Her veil was pulled over her head to create an effect similar to that shown in plate 187. The primary difference is the lighting.

The light for this image came from a window on the back wall and a window and glass door located on a perpendicular wall, off to camera left. The room had a relatively low, white ceiling that reflected light across the composition; therefore, there is one f-stop less light at the right of the image. With this in mind, the exposure

was calculated at the highlight side. Because the subject was positioned sideways to the main light there is a 3:1 ratio. Note that there is almost a split lighting pattern, but because the light caught the veil on the left side of her face, it is less obvious. See diagram 30.

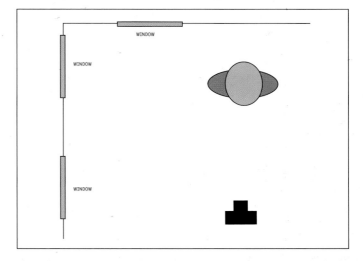

PLATE 187 (BELOW); DIAGRAM 30 (RIGHT)

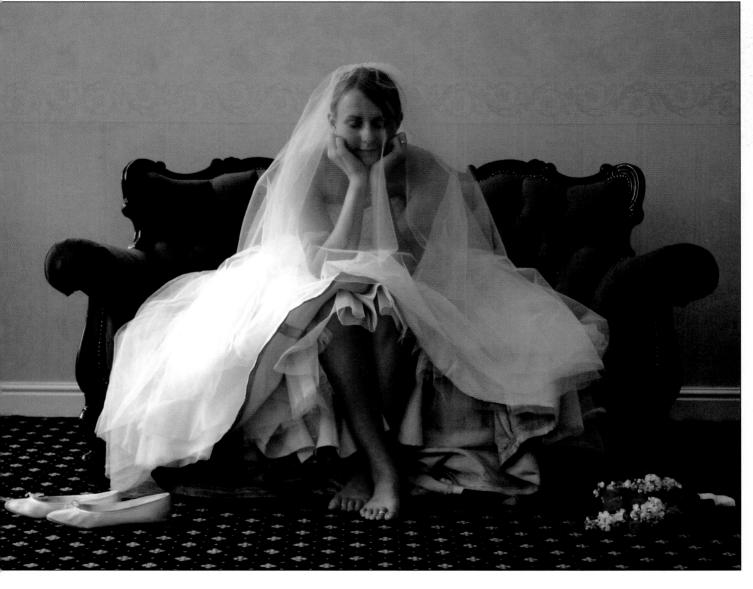

16. Image Dynamics

In this chapter, we'll take a second look at one image from each of the preceding chapters. We'll evaluate the dynamics of each image to discover more about the photographer's approach and style and to learn what separates their images from the work of their peers.

Kerry Firstenleit's portrait of the elderly lady in plate 14 (page 14) demonstrates elegance and style in a composition that is as good as any we will see. Kerry's use of window light is exemplary and the pose has great lines

that lead to the woman's beautifully illuminated face. Note that the composition provides us with some clues about the woman's lifestyle as some of her personal belongings are shown. A portrait should ideally be about who the person is, not just an image of their face.

Michael Ayers' portrait of an exquisitely posed bride in plate 28 (page 21) is an excellent example of how to use window light. By including the window in the image, Michael created an added sense of dimension in the image. In a portrait, the lighting, pose, and composition should always be in harmony, and Michael has achieved that here

Andrea Barrett's portrait of a bride in plate 37 (page 26) is in keeping with the photojournalistic images in fashion magazines. The image meets a demand by the modern bride for something more spontaneous—and something that looks a little different than the images in all of her friends' wedding albums.

PLATE 14 (TOP LEFT); PLATE 28 (LEFT); PLATE 37 (ABOVE)

PLATE 43 (ABOVE); PLATE 48 (TOP RIGHT); PLATE 68 (RIGHT)

Klarke Caplin's image in plate 43 (page 31) is an excellent example of spontaneous portraiture. It captures the subject's spirit and suggests energy. The movement in the subject's hair and her wonderful expression combine to tell a great story about a moment in time—a story with abundant feminine charm.

If we want to create a desire to reach into the shadows to discover more about a subject, we will be well served to study Tony Corbell's portrait in plate 48 (page 34). Sometimes what we do not show in an image is more interesting than what we include. Tony shows just enough to draw our gaze but leaves us wanting more.

It is often said that the eyes are the windows to the soul. If this is true, then the portrait shown in plate 68 (page 45) illustrates that theory. Rick Ferro created perfect lighting on his subject's face. Note the strong butterfly-shaped shadow below her nose and 3:1 ratio. With the subject in relief against the dark background, Rick draws our attention immediately to the subject's eyes, which were beautifully illuminated. No matter how many times we revisit the portrait, the eyes are what we first see and we cannot escape them.

If we are looking for a dynamic portrait of a woman, we need look no farther than plate 78 (page 51) by Jeff and Kathleen Hawkins. Tilting the camera allowed for the sweeping diagonal from the bottom left to the top

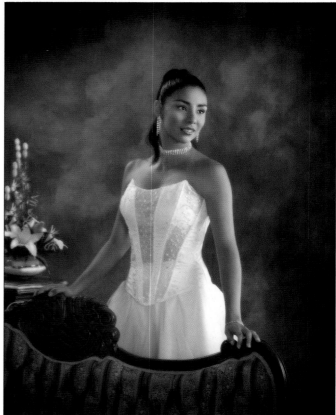

PLATE 78 (ABOVE); PLATE 96 (TOP RIGHT); PLATE 100 (RIGHT)

right of the frame that draws attention to the woman's curvaceous pose. Many images that feature a diagonal composition contain props that make us wonder why the photographer angled his camera. In this image the positive impact created by tilting the camera is obvious.

If we are looking for a lesson in composition and lighting a group of women, Mark Laurie's image in plate 96 (page 61) is perfect. The composition is excellent; note that no head is positioned at the same height or in the same line as another. There is also a beautiful implied curved line around the subjects' heads. The placement of the mother at the back is fundamentally on target.

Plate 100 (page 63) by Dave Newman shows a perfect example of classical posing and lighting that transcends time. Many photographers fail to master lighting techniques and then seek to correct flaws with sophisticated software. This image shows the impact of careful, well-executed lighting that flatters the subject and shows her at her best. The pose is also elegant and flattering.

When I analyzed Tom Lee's portrait in plate 116 (page 72) I suggested that the reason for including it, despite it being a nude, was that it showed how we may use light from above to create something very different. The

traditional rules of portraiture advise us to avoid lighting from directly above the subject because of its potential to create ugly shadows. In this image, Tom shows how wrong that rule can sometimes be. He created an image with strong contrast and proved that such a lighting setup can present a feminine quality.

Paul Rogers has also defied convention in his bridal portrait in plate 127 (page 79). We are told that when photographing women, we should not create strong con-

trast, as it supposedly is not feminine. This image proves that we can use contrast to our advantage in photographing women—when we know what we are doing.

There are numerous shadows in this portrait that normally would be considered inappropriate, yet the image is delightfully feminine in a very nice composition. The rendering of the subject's gown, arm, and face is very pleasing, and the overall effect breaks new ground.

The portrait by Sheila Rutledge shown in plate 136 (page 84) is an outstanding example of portrait lighting technique. Note that any differential in lighting is indiscernible across the woman's hair. In this "open face" style of portraiture, the mask of the face is evenly highlighted and all of the shadow areas are equally rendered. The transition from the highlight to shadow areas is beautifully smooth. The lighting, pose, and the expression in the subject's eyes all come together nicely.

When we discuss style, we seek to define its source. Some of us have great skills that allow us to create quality images in a variety of disciplines, but Edda Taylor's signature style is a result of her quest to capture the body and soul of her subjects. Her portrait in plate 149 (page

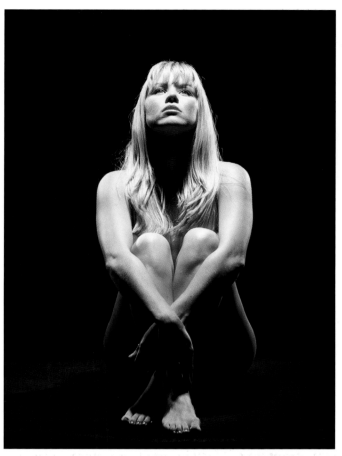

PLATE 116 (TOP RIGHT); PLATE 127 (BOTTOM LEFT); PLATE 136 (BOTTOM RIGHT)

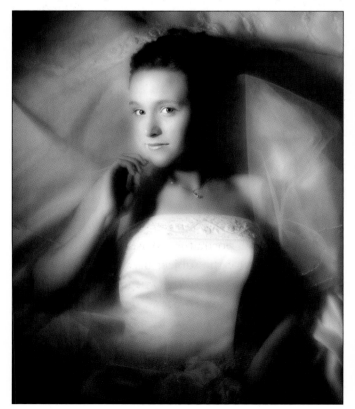

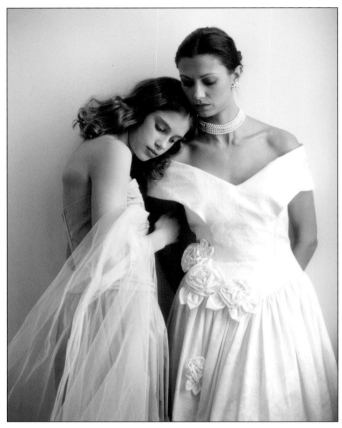

PLATE 149

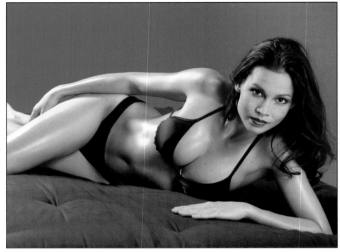

PLATE 164

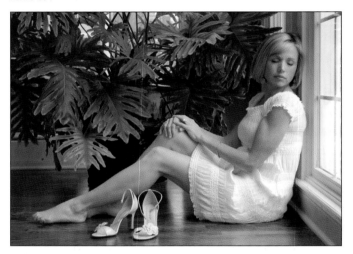

PLATE 181

93) has a style that is rarely seen in professional portraiture. The image has spontaneous emotion. The younger subject's connection to the elder shows empathy, and the intended story line is immediately evident to any viewer. The way the younger of the two women is posed tells a story that needs no words. The image looks natural and spontaneous, and the soft lighting perfectly matches the composition.

From Stephen Dantzig's images in chapter 14, I selected plate 164 (page 102)—an image that is delightfully feminine. Both the pose and the lighting show the subject's figure to great effect, making it a shot that is sure to appeal to male and female viewers alike.

From my own images, I selected plate 181 (page 109), as I see it as an example of how light control and posing are inseparable disciplines. Note that the subject's position in the set and the introduction of a reflector resulted in a composition in which every element was evenly illuminated. The pose is soft and sensual, showing her great legs to advantage. Note the many diagonal lines and triangular elements in the image.

Conclusion

When I solicited images from the photographers included in this book I thought I had some idea as to what to expect, as I have been familiar with them or their work for some time. In my solicitation all I asked was that the images be fresh and recent. But as I worked my way though the ensuing chapters, I was often surprised because many of the images provided did not conform to my expectations. In fact, I found myself fascinated by the variety of images each photographer provided.

Earlier I suggested that what is included was for enlightenment, inspiration, and education. We are lucky because the diversity of style and approach has something for everyone, and there are many images that are outstanding examples of the technique used to create them.

In previous books I have covered lighting and posing, demonstrating what I believe to be the fundamentals to these techniques. In the images analyzed in these pages, many of my rules have been broken and with style. In fact, if you go back over the images we have discussed and compare some of the posing I have advocated, you will see how the outstanding practitioners represented in this book use techniques that don't just break the rules but break them to advantage.

But all the set rules are but a starting point, and if we are to be successful we need to be able to innovate, using the rules as a base for creativity. By studying the portraits in these chapters you will discover there are different techniques for creating images than those you presently use. You can ape them or use them as inspiration for your own creations. Remember that being different is as important as being better.

Throughout I have constantly referred to leading lines and composition. I have also focused on lighting technique and how it models the subject. The fundamentals in these skills are vital to effective portraiture and photography in general, and we need to memorize them so that when we break them we have solid reason, because if we don't our images will be less than is desirable and possibly plain bad.

My analysis of the images is intended to draw your attention to elements that are important in both design and technique and to prevent readers from simply scanning them but to encourage you to do the same. We are all drawn to review our colleagues' images. We often see images that we admire yet may not want to create our images in the same way. But analyzing images for lighting, posing, and compositional qualities is educational. Analyzing those in this book has been educational and inspirational for me too.

I hope that due to the inspiration from images showcased in this book I will have the pleasure of using your images in a future book.

Glossary

Background light. A light directed onto the background to create separation between the subject and the background.

Balancing the light. To balance the light is to use two or more complementary light sources so that between them they create a very gentle transition from highlight to shadow in which there is never more than a 3:1 ratio across the facial plane.

Blown out. Term that describes the effect of too much light on an area, which causes it to render as pure white without detail.

Broad lighting. A technique in which the broad side of the face receives the main light and the far side of the face is allowed to fall into shadow.

Butterfly lighting pattern. A butterfly lighting pattern is created when the main light produces a butterfly-shaped shadow in the area between the smile line on the shadow side of the face, the upper lip, and immediately below the nose.

Camera plane. The camera plane is a horizontal line that runs directly across the camera position as it relates to the position of the subject. The subject is at the center of a circle and the camera is at the outside edge of the circle so we are able to move lights around an invisible circle at different degrees.

Chicken leg. A "chicken leg" impression occurs when a limb is coming directly toward the camera, causing it to appear foreshortened and look like a chicken leg.

Continuous lighting. Non-flash lighting, where the light remains on throughout the session. These lights are generally photoflood bulbs also referred to as "hot" lighting.

Cross processing. This is a technique in which film is deliberately processed in chemicals not designed for the particular film in order to obtain results other than what the film was designed to produce.

Diffuser. An accessory made of any of various materials that scatters light to soften the illumination.

Domed reflector. A large silvered pan reflector or a silvered umbrella used to reflect light.

Dragging the shutter. Setting the shutter speed for a setting longer than the flash sync speed to allow more ambient light to register in the image and allow the recording of detail in areas not illuminated by flash.

Feathering the light. This is the technique of directing the light across the plane of the subject from a comparatively sharp angle or turning the light away from the plane of the subject. The former is termed feathering out and the latter is called feathering in.

Halo Mono. The Halo Mono is a product by F. J. Westcott. It is an umbrella that has a second umbrella made of diffusing material placed in front of the base umbrella construction. This produces a wide coverage of light that is softer than that produced by a standard umbrella.

High, low, and middle key. The overall density of an image that is equal to 18 percent gray determines middle key. Low key is when the overall density is one or more f-stops deeper than 18 percent gray, while high key is achieved when the overall density is half an f-stop or more lighter than 18 percent gray.

Hot lights. Tungsten photofloods or halogen lights that produce a continuous (nonflash) light and become very warm or hot with use (hence the "hot" light). The use of hot lights is also referred to as continuous lighting.

Kicker light. A light that provides edge or back lighting and is used to create a sense of a third dimension. This

light is usually placed behind the plane of the subject and primarily to one side.

Loop lighting pattern. This is a lighting pattern that creates a tight, distinct shadow line below the subject's nose.

Main light. The light that determines the primary lighting pattern.

Mask of the face. The forehead, cheeks, the nose, and chin.

Pan reflector. A pan reflector is a parabolic pan-shaped modifier and in most cases has a central deflector to diffuse the light around the pan. This modifier produces a very flat bright but bright light that is most appropriate when producing glamour portraits with the light close to the subject at the same position as the camera. Some pan reflectors have attachments that provide a form of vignette as its coverage falls off at the edges and, when used accurately, creates a controlled portrait lighting tool. However, it is not the same as a conventional vignette.

Proud head pose. In the proud head pose, the subject's head is positioned in a virtual straight line over the torso with the forehead very slightly tipped toward the camera.

Ratio. A numerical description of the difference between the highlight and shadow areas in an image. The ratio is calculated by adding each ½ of an f-stop difference between the main light and the fill light to the exposure for the highlight. Hence, an f/8 highlight exposure and an f/5.6 fill light exposure create a 3:1 ratio.

Reflectors. Reflectors are accessories used to bounce light. The reflective surfaces are commonly available in silver, gold, and white. A silver reflector produces a specular effect, a white reflector produces a softer light, and a gold reflector is used to produce a warm light quality. There are other colors available that can be used to fill a particular need for any given assignment. Photographers can also choose from a variety of surfaces, from highly reflective to matte, depending on their needs. Some reflectors are transparent. These filter light and are used to reduce the specularity of light or to reduce its intensity (for instance, to soften the effect of sunlight when working outdoors).

Reflectors come in a variety of sizes and shapes. Very large sizes (say, reflectors measuring 10 feet) are suitable for coverage of a large subject or area. More portable reflectors are commonly taken on location for assignments such as outdoor portraits. Some reflectors can be employed with the flick of the wrist and folded away with the same action, then stored in a special carrying case. These are available in sets of three.

Snoot. A snoot is a tubular accessory that is used to create a narrow, nonfocusable spotlight effect. Snoots are available in 8 to 12 inch lengths (depending on the make). The light produced with a snoot is contrasty in nature. It is sometimes used as a hair light or to create a spot of light on the background.

Reflector bank. The technique of using one or more reflectors to create a large area of reflected light.

S curve. An S curve is a desirable composition in posing female subjects. The curve is created by having the subject position her legs, hips, waist, shoulders, and head to angle in different directions in a curvaceous, S-shaped line.

Scrim. A scrim is a semi-opaque material that is placed in front of a light source to diffuse or soften the light.

Softbox. A softbox is a box-shaped modifier that directs diffused light through a front panel, producing a bigger, softer light effect. Many softboxes provide a second, removable layer of diffusion material. This double produces a much softer light than single diffusion. Softboxes are available in a wide range of sizes and configurations and from various manufacturers and suppliers.

Softboxes are manufactured with a wide variety of internal surfaces, including white (which produces a soft light), silver (which produces a harsher light), and 18 percent gray (which produces the softest light).

Many softboxes have a recessed front panel diffuser, which allows for more control over the direction of the light. Additionally, some manufacturers, such as F. J. Westcott, provide kits with the purchase of a softbox that includes accessories that attach to the front of the box and narrow the source of the light, providing greater control.

Split lighting. Split lighting is a technique in which only one side of the subject's features are illuminated and other side has no visible detail.

Strip bank. A strip bank is a narrow softbox that will extend in length up to 72 inches. Most of these units are

no deeper than 10 inches and are often employed as hair lights. They are most appropriate when a narrow strip of light is required. Its narrow coverage offers greater control than a larger-size softbox. Egg-crate accessories are available for more precise control.

Strip blockers. Most softbox kits come with accessories that can be affixed to the front of the softbox to modify the light. One such modifier is comprised of strips that can be attached to the front diffusing scrim to narrow the source of light to provide additional control.

Submissive head pose. The action of tipping the subject's head to the shoulder nearest to the camera, which creates a weak or submissive appearance.

Synchro flash technique. This technique requires the flash exposure to match as closely as possible the exposure required to record the natural light behind the subject. This may be slightly varied as desired.

Tri-flector. A tri-flector is a light modifier comprised of three silver reflectors hinged together. It is generally used in front of the subject to direct light into the face from a low position.

Umbrellas. Umbrellas may well be the most popular type of light modifier available, and they come in numerous sizes and configurations. Because umbrella light is projected over an area significantly larger than its own width, a very wide source of light is produced, which, in comparison to the light output by a softbox, is more difficult to control. Of course, the spread of light that umbrellas produce can be useful, and the size you select should be based on the area you wish to cover.

Umbrellas have the same surface options as softboxes, including silver, silver/white, gold, and white. Diffusers are also available for some umbrella types.

Two unique umbrellas are the Halo and Halo Mono, produced by F. J. Westcott. These umbrellas have a reverse umbrella in front of the base umbrella construction that provides a wide coverage of soft light. The Halo Mono's construction allows you to access the controls on the rear of your mono light. These models are available in several sizes.

Note: All the F. J. Westcott equipment/accessories described above are available at www.normanphillipsseminars.com or by calling 800.792.2092.

Index

SUCCESS IN PORTRAIT PHOTOGRAPHY

Jeff Smith

Camera skills alone do not ensure success. This book will teach photographers how to run savvy marketing campaigns, attract clients, and provide top-notch customer service. $29.95 list, 8.5x11, 128p, 100 color photos, order no. 1748.

THE BEST OF TEEN AND SENIOR PORTRAIT PHOTOGRAPHY

Bill Hurter

Learn how top professionals create stunning images that capture the personality of their teen and senior subjects. $34.95 list, 8.5x11, 128p, 150 color photos, index, order no. 1766.

THE PORTRAIT BOOK
A GUIDE FOR PHOTOGRAPHERS

Steven H. Begleiter

A comprehensive textbook for those getting started in professional portrait photography. Covers every aspect from designing an image to executing the shoot. $29.95 list, 8.5x11, 128p, 130 color images, index, order no. 1767.

THE BEST OF WEDDING PHOTOJOURNALISM

Bill Hurter

Learn how top professionals capture these fleeting moments of laughter, tears, and romance. Features images from over twenty renowned wedding photographers. $34.95 list, 8.5x11, 128p, 150 color photos, index, order no. 1774.

PORTRAIT PHOTOGRAPHY
THE ART OF SEEING LIGHT

Don Blair with Peter Skinner

Learn to harness the best light both in studio and on location, and get the secrets behind the magical portraiture captured by this legendary photographer. $29.95 list, 8.5x11, 128p, 100 color photos, index, order no. 1783.

POWER MARKETING FOR WEDDING AND PORTRAIT PHOTOGRAPHERS

Mitche Graf

Set your business apart and create clients for life with this comprehensive guide to achieving your professional goals. $29.95 list, 8.5x11, 128p, 100 color images, index, order no. 1788.

POSING FOR PORTRAIT PHOTOGRAPHY
A HEAD-TO-TOE GUIDE

Jeff Smith

Author Jeff Smith teaches surefire techniques for fine-tuning every aspect of the pose for the most flattering results. $34.95 list, 8.5x11, 128p, 150 color photos, index, order no. 1786.

PROFESSIONAL MODEL PORTFOLIOS
A STEP-BY-STEP GUIDE FOR PHOTOGRAPHERS

Billy Pegram

Learn to create portfolios that will get your clients noticed—and hired! $34.95 list, 8.5x11, 128p, 100 color images, index, order no. 1789.

THE PORTRAIT PHOTOGRAPHER'S
GUIDE TO POSING

Bill Hurter

Posing can make or break an image. Now you can get the posing tips and techniques that have propelled the finest portrait photographers in the industry to the top. $34.95 list, 8.5x11, 128p, 200 color photos, index, order no. 1779.

MASTER LIGHTING GUIDE
FOR PORTRAIT PHOTOGRAPHERS

Christopher Grey

Efficiently light executive and model portraits, high and low key images, and more. Master traditional lighting styles and use creative modifications that will maximize your results. $29.95 list, 8.5x11, 128p, 300 color photos, index, order no. 1778.

CLASSIC PORTRAIT PHOTOGRAPHY

William S. McIntosh

Learn how to create portraits that stand the test of time. Master photographer Bill McIntosh discusses his best images, giving you an inside look at his timeless style. $29.95 list, 8.5x11, 128p, 100 color photos, index, order no. 1784.

LIGHTING TECHNIQUES FOR
FASHION AND GLAMOUR PHOTOGRAPHY

Stephen A. Dantzig, PsyD.

In fashion and glamour photography, light is the key to producing images with impact. With these techniques, you'll be primed for success! $29.95 list, 8.5x11, 128p, over 200 color images, index, order no. 1795.

Books by
Featured Photographers ...

WEDDING PHOTOGRAPHY
CREATIVE TECHNIQUES FOR LIGHTING, POSING, AND MARKETING, 3rd Ed.

Rick Ferro

Creative techniques for lighting and posing wedding portraits that will set your work apart from the competition. Covers every phase of wedding photography. $34.95 list, 8.5x11, 128p, 125 color photos, index, order no. 1649.

WEDDING PHOTOGRAPHY WITH ADOBE® PHOTOSHOP®

Rick Ferro and Deborah Lynn Ferro

Get the skills you need to make your images look their best, add artistic effects, and boost your wedding photography sales with savvy marketing ideas. $34.95 list, 8.5x11, 128p, 100 color images, index, order no. 1753.

THE BRIDE'S GUIDE TO WEDDING PHOTOGRAPHY

Kathleen Hawkins

Learn how to get the wedding photography of your dreams with tips from the pros. Perfect for brides (or photographers preparing clients for their wedding photography). $14.95 list, 9x6, 112p, 115 color photos, index, order no. 1755.

DIGITAL PHOTOGRAPHY FOR CHILDREN'S AND FAMILY PORTRAITURE

Kathleen Hawkins

Discover how digital photography can boost your sales, enhance your creativity, and improve your studio's workflow. $29.95 list, 8.5x11, 128p, 130 color images, index, order no. 1770.

PROFESSIONAL TECHNIQUES FOR DIGITAL WEDDING PHOTOGRAPHY, 2nd Ed.

Jeff Hawkins and Kathleen Hawkins

From selecting equipment, to marketing, to building a digital workflow, this book teaches how to make digital work for you. $34.95 list, 8.5x11, 128p, 85 color images, order no. 1735.

MARKETING & SELLING TECHNIQUES
FOR DIGITAL PORTRAIT PHOTOGRAPHY

Kathleen Hawkins

Great portraits aren't enough to ensure the success of your business! Learn how to attract clients and boost your sales. $34.95 list, 8.5x11, 128p, 150 color photos, index, order no. 1804.

ARTISTIC TECHNIQUES WITH ADOBE® PHOTOSHOP® AND COREL® PAINTER®

Deborah Lynn Ferro

Flex your creativity and transform photographs into fine-art masterpieces. Step-by-step techniques make it easy! $34.95 list, 8.5x11, 128p, 200 color images, index, order no. 1806.

MONTE ZUCKER'S PORTRAIT PHOTOGRAPHY HANBOOK

Internationally acclaimed portrait photog-rapher Monte Zucker takes you behind the scenes and shows you how to create a "Monte Portrait." Covers clothing selection, posing, lighting, and much more—with techniques for both studio and location shoots. $34.95 list, 8.5x11, 128p, 200 color photos, index, order no. 1846.

THE BEST OF PHOTOGRAPHIC LIGHTING

Bill Hurter

Top professionals reveal the secrets behind their successful strategies for studio, location, and outdoor lighting. Packed with tips for portraits, still lifes, and more. $34.95 list, 8.5x11, 128p, 150 color photos, index, order no. 1808.

DIGITAL PHOTOGRAPHY BOOT CAMP

Kevin Kubota

Kevin Kubota's popular workshop is now a book! A down-and-dirty, step-by-step course in building a professional photography workflow and creating digital images that sell! $34.95 list, 8.5x11, 128p, 250 color images, index, order no. 1809.

PROFESSIONAL DIGITAL TECHNIQUES FOR **NUDE & GLAMOUR PHOTOGRAPHY**

Bill Lemon

Master the skills you need to create beautiful nude and glamour images—digitally. Includes lighting, posing, and much more. $34.95 list, 8.5x11, 128p, 110 color photos, index, order no. 1816.

MASTER LIGHTING TECHNIQUES

FOR OUTDOOR AND LOCATION DIGITAL PORTRAIT PHOTOGRAPHY

Stephen A. Dantzig

Use natural light alone or with flash fill, barebulb, and strobes to shoot perfect portraits all day long. $34.95 list, 8.5x11, 128p, 175 color photos, diagrams, index, order no. 1821.

BEGINNER'S GUIDE TO ADOBE® PHOTOSHOP®, 3rd Ed.

Michelle Perkins

Enhance your photos or add unique effects to any image. Short, easy-to-digest lessons will boost your confidence and ensure outstanding images. $34.95 list, 8.5x11, 128p, 80 color images, 120 screen shots, order no. 1823.

PROFESSIONAL PORTRAIT LIGHTING

TECHNIQUES AND IMAGES FROM MASTER PHOTOGRAPHERS

Michelle Perkins

Get a behind-the-scenes look at the lighting techniques employed by the world's top portrait photographers. $34.95 list, 8.5x11, 128p, 200 color photos, index, order no. 2000.

RANGEFINDER'S PROFESSIONAL PHOTOGRAPHY

edited by Bill Hurter

Editor Bill Hurter shares over one hundred "recipes" from *Rangefinder's* popular cookbook series, showing you how to shoot, pose, light, and edit fabulous images. $34.95 list, 8.5x11, 128p, 150 color photos, index, order no. 1828.

MASTER GUIDE FOR GLAMOUR PHOTOGRAPHY

Chris Nelson

Establish a rapport with your model, ensure a successful shoot, and master the essential digital fixes your clients demand. Includes lingerie, semi-nude, and nude images. $34.95 list, 8.5x11, 128p, 200 color photos, index, order no. 1836.

SOFTBOX LIGHTING TECHNIQUES

FOR PROFESSIONAL PHOTOGRAPHERS

Stephen A. Dantzig

Learn to use one of photography's most popular lighting devices to produce soft and flawless effects for portraits, product shots, and more. $34.95 list, 8.5x11, 128p, 260 color images, index, order no. 1839.

ROLANDO GOMEZ'S GLAMOUR PHOTOGRAPHY

PROFESSIONAL TECHNIQUES AND IMAGES

Learn how to create classy glamour portraits your clients will adore. Rolando Gomez takes you behind the scenes, offering invaluable technical and professional insights. $34.95 list, 8.5x11, 128p, 150 color images, index, order no. 1842.

PROFESSIONAL PORTRAIT POSING

TECHNIQUES AND IMAGES FROM MASTER PHOTOGRAPHERS

Michelle Perkins

Learn how master photographers pose subjects to create unforgettable images. $34.95 list, 8.5x11, 128p, 175 color images, index, order no. 2002.